MONTAUK 11954

MONTAUK
11954

**PHOTOGRAPHS BY
CAR PELLETERI**

Schiffer Publishing Ltd

4880 Lower Valley Road • Atglen, PA 19310

DEDICATION

**To my son, Leo, and all the little ones
who enjoy digging in the sand**

INTRODUCTION

My first visit to Montauk was in the summer of 2000. I was a photographer's assistant, and it was many tides ago, yet I remember the trip like it was yesterday. A crew of us drove out from the city in an RV. I had heard from my friends about this special place, and I was filled with anticipation. We hit traffic, and the drive through Long Island took time, but finally we arrived at East Deck Motel. Stepping out onto the parking lot at Ditch Plains, the famed beach hideaway, I was immediately intrigued by the land, the surf, and the people. East Deck Motel was a true haven. My room was dated, yet so cool in a way I appreciated. It had wood paneling, a surfer painting on the wall, and a percolator coffee pot, which reminded me of my grandparents. I could see, hear, and smell the ocean just feet away, and I was hooked. When it was time to work, we photographed just yards away on Ditch Beach, and later in magnificent Hither Hills. We experienced the cliffs, called the Hoodoos—walking on top of them, walking below them on the sand—and the endless bounty of delicious seafood. I wanted to stay all summer. This was the beginning of my fascination with a unique place all the way out on Long Island known as "The End."

Car Pelleteri

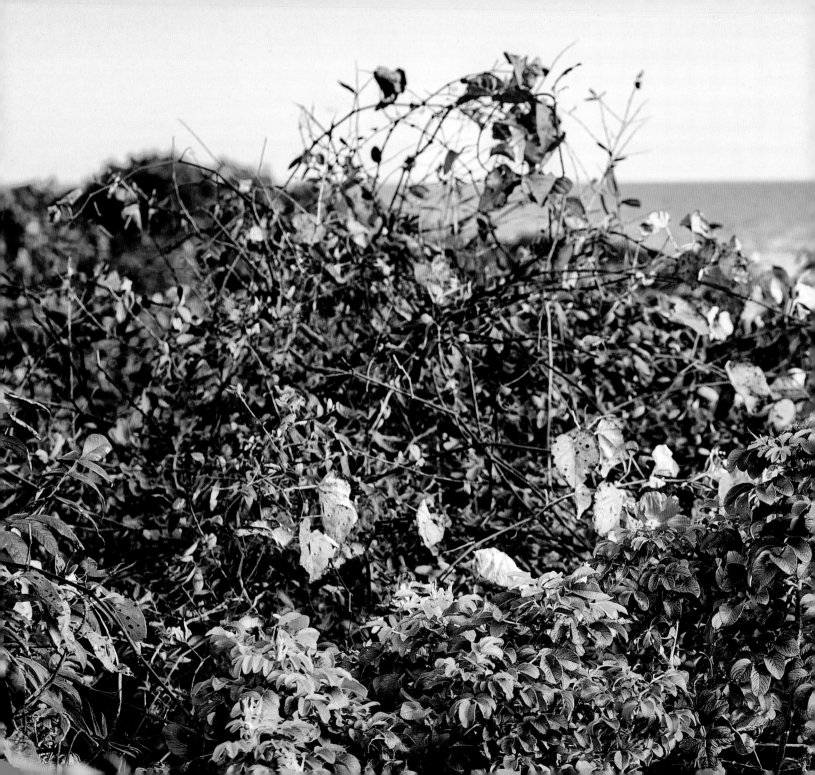

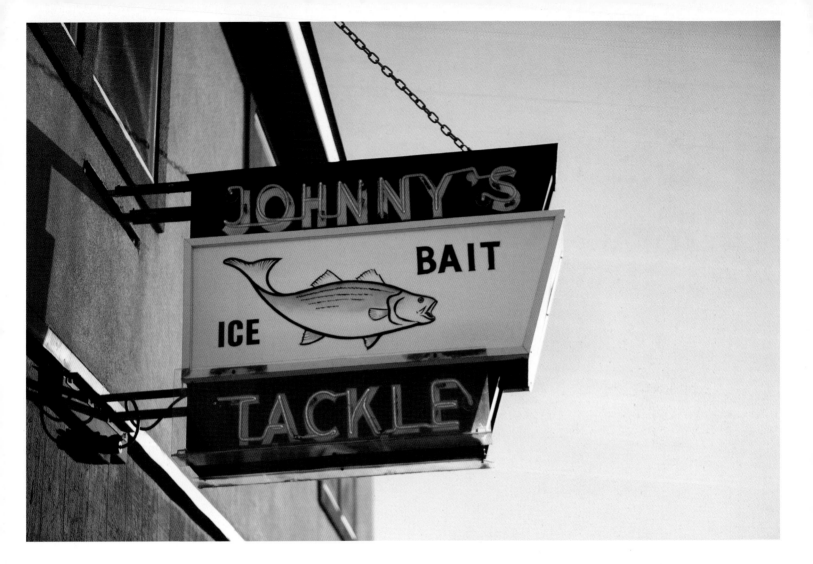

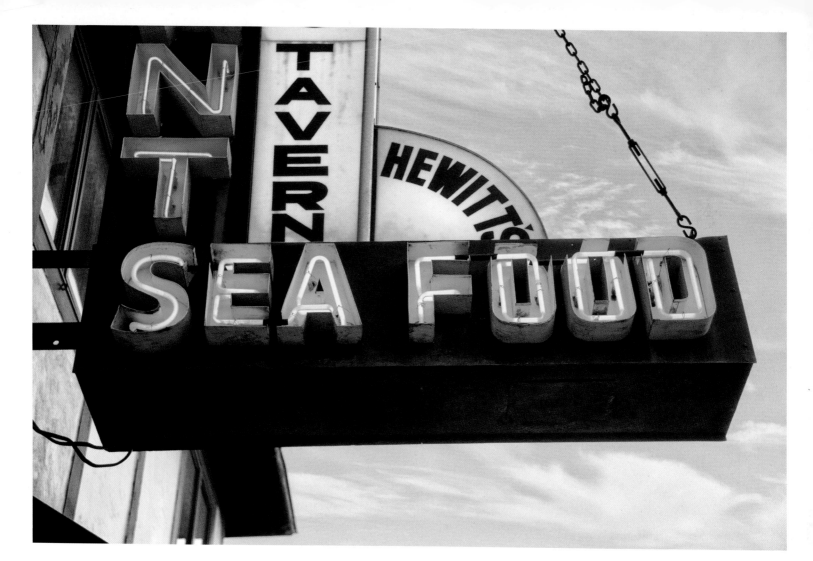

NO ♥ PLACE

😊 LIKE 😎

MONTAUK

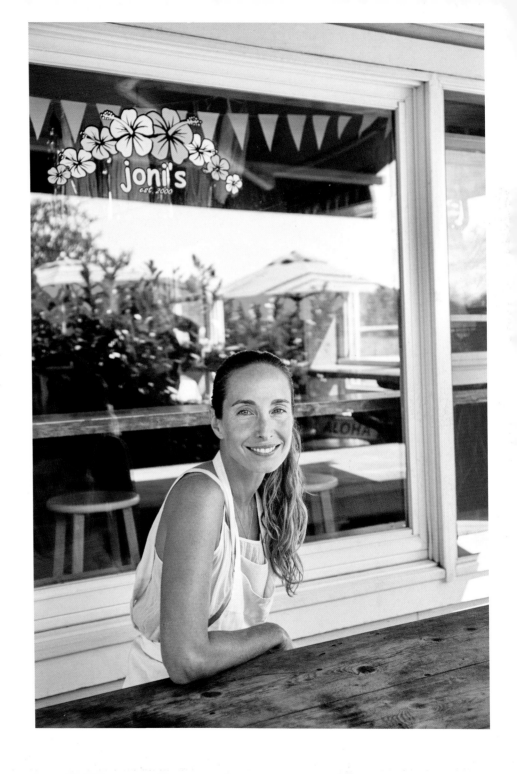

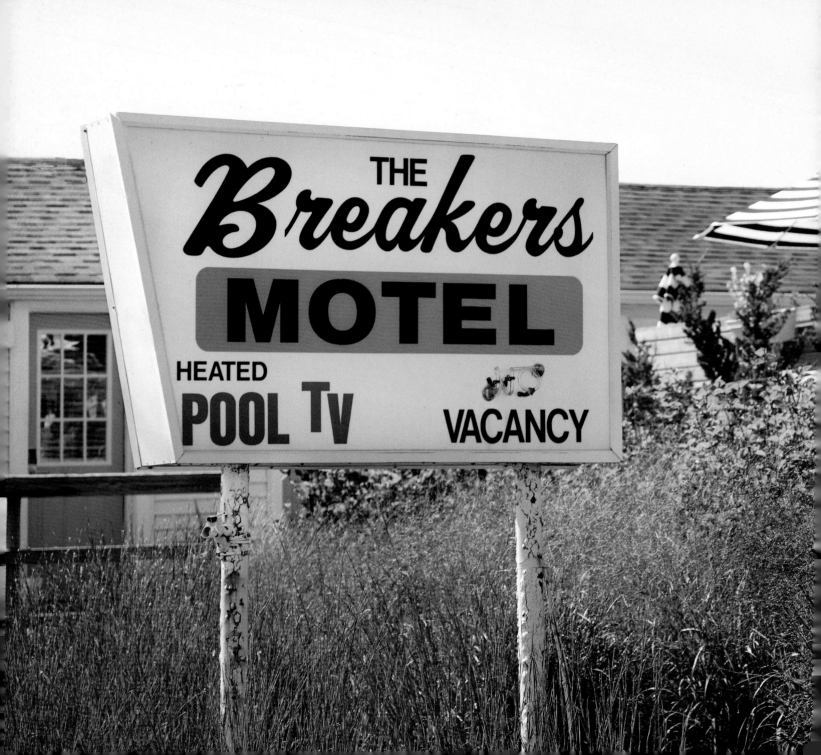

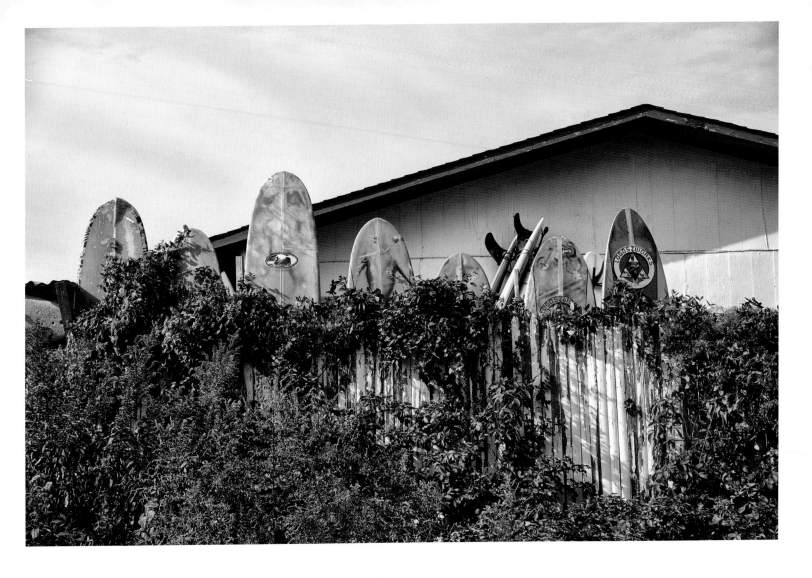

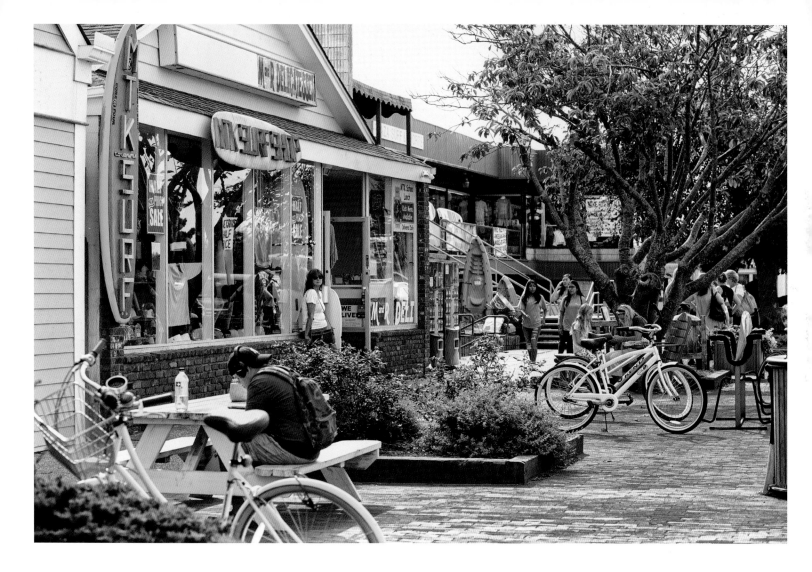

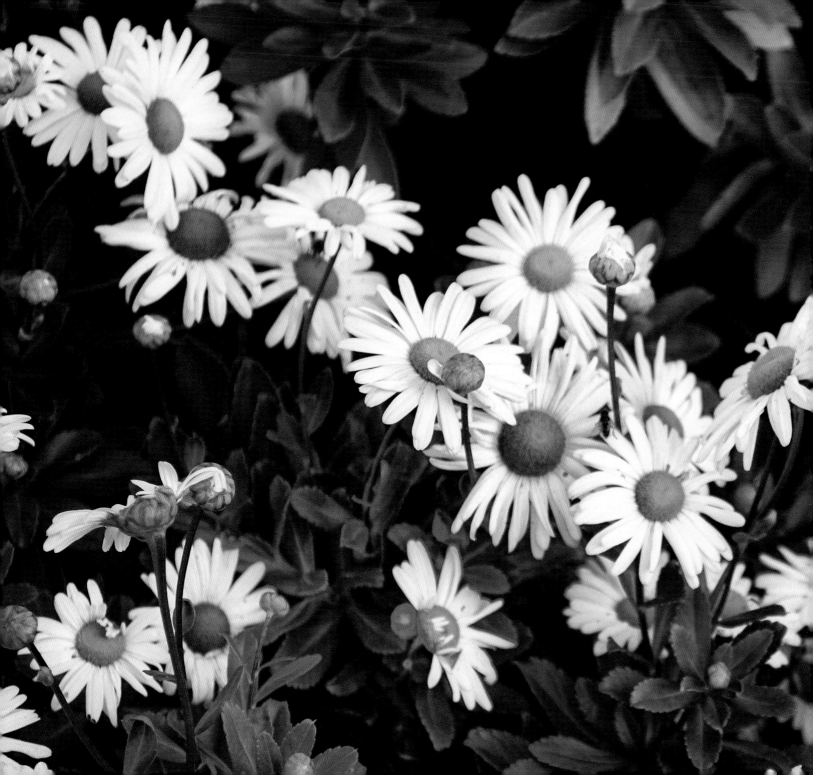

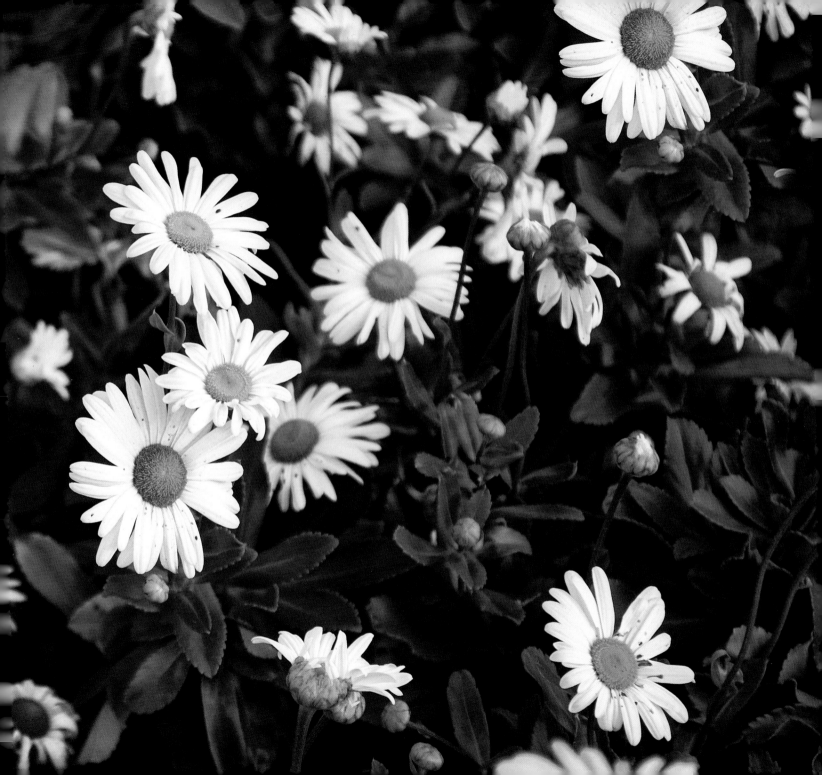

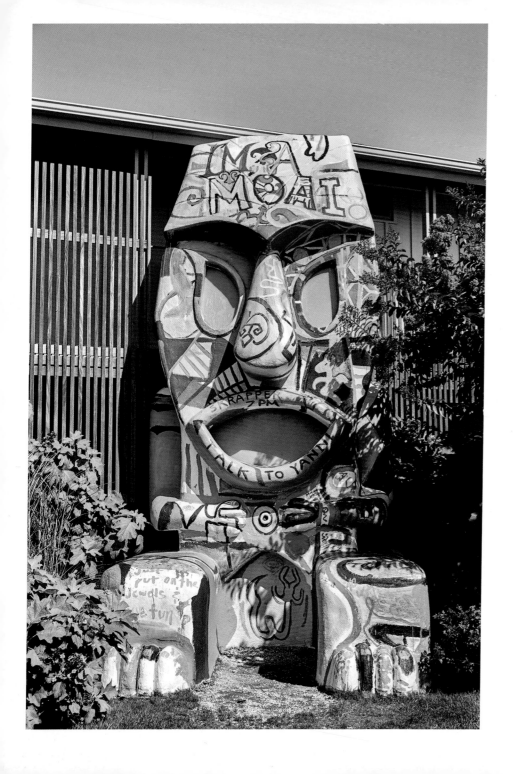

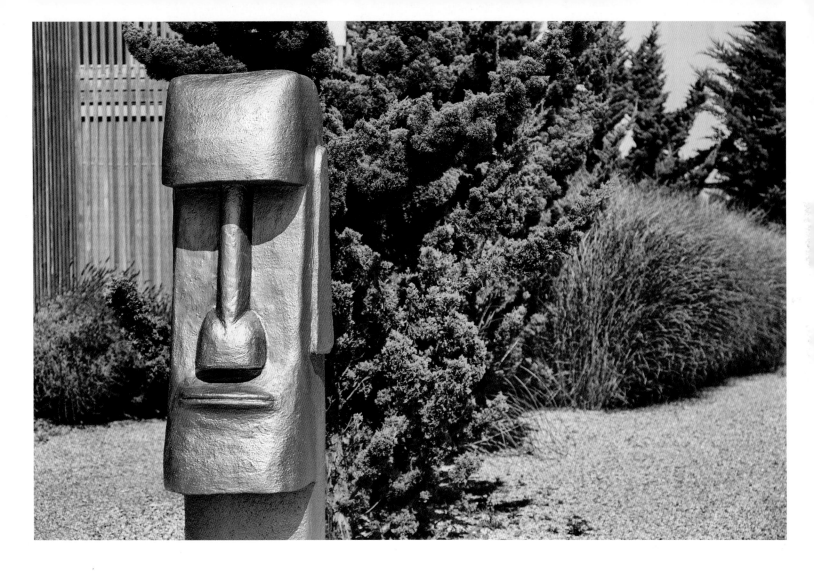

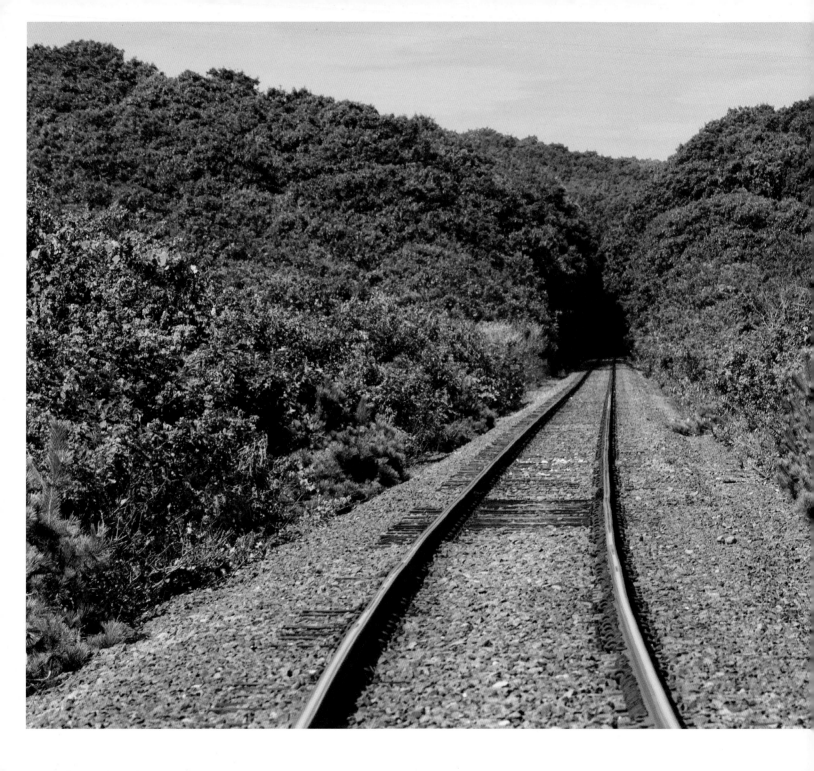

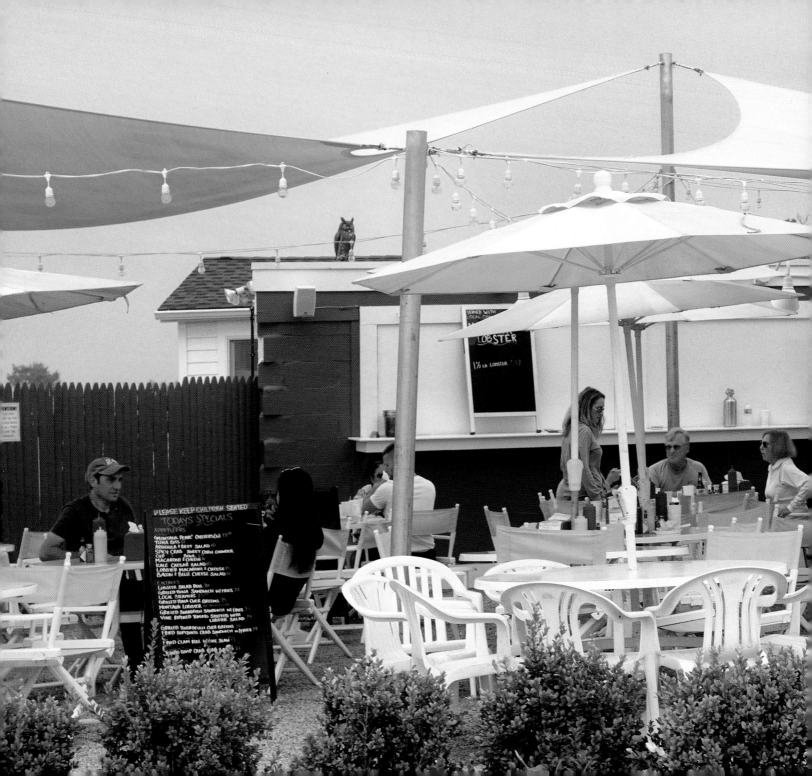

PLEASE KEEP CHILDREN SEATED
TODAYS SPECIALS
APPETIZERS
'MONTAUK PEARL' OYSTERS(6) $13⁰⁰
TUNA BITS 15
ARUGULA & BEET SALAD 10
SOFT CRAB SWEET CORN CHOWDER
CUP BOWL
MACARONI & CHEESE 8
KALE CAESAR SALAD 10
LOBSTER MACARONI & CHEESE 15
BACON & BLUE CHEESE SALAD 6

ENTREES
LOBSTER SALAD ROLL 26
GRILLED TUNA SANDWICH W/ FRIES 22
LOCAL STEAMERS 20
GRILLED LOBSTER OVER GREENS 35
MONTAUK LOBSTER AU NATURALE
GRILLED SWORDFISH SANDWICH W/ FRIES 25
VINE RIPENED TOMATO STUFFED WITH 24
 LOBSTER SALAD

GRILLED SWORDFISH OVER GREENS 29
FRIED SOFTSHELL CRAB SANDWICH W/ FRIES 19

FRIED CLAM ROLL W/ THE SLAW

JUMBO LUMP CRAB SANDWICH 23

SERVED WITH
LOCAL CORN
LOBSTER
1½ LB LOBSTER $37

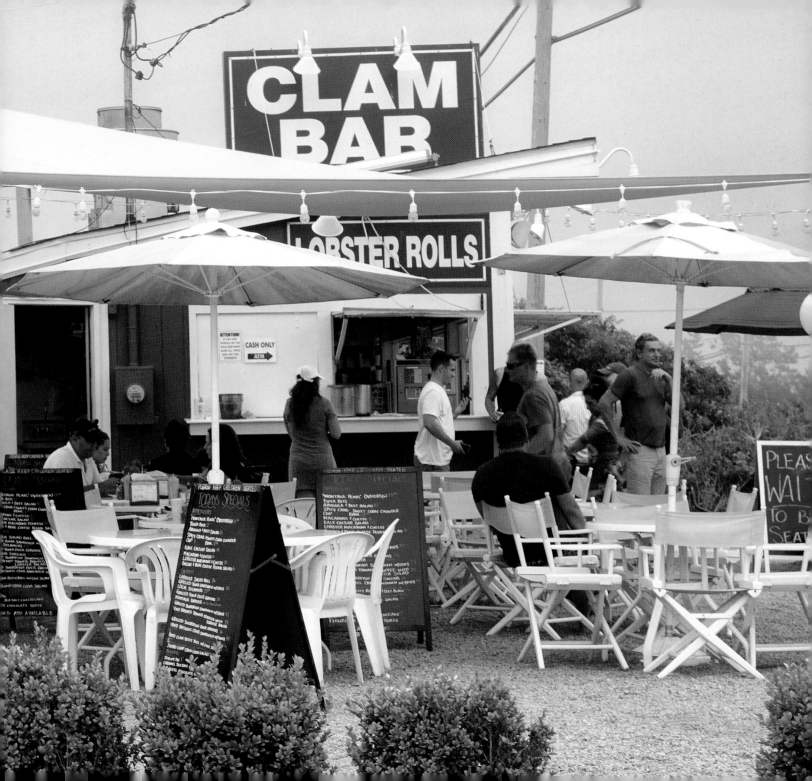

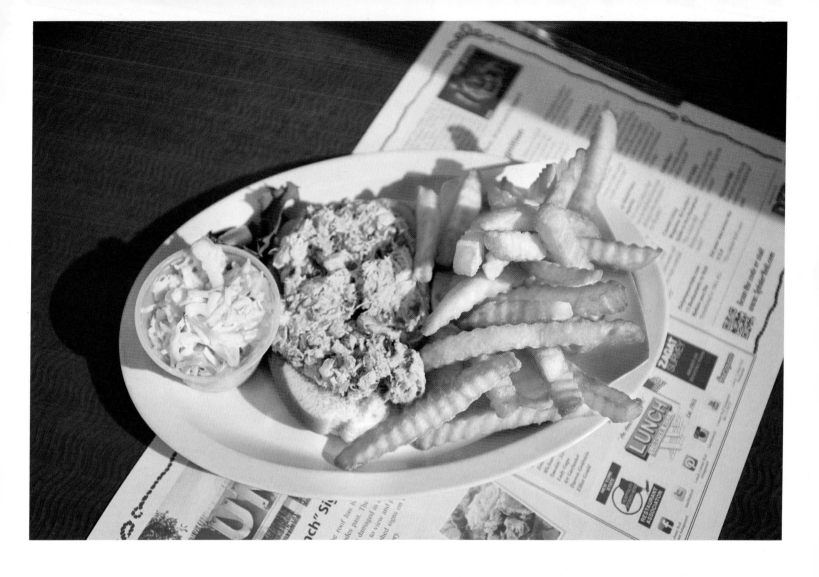

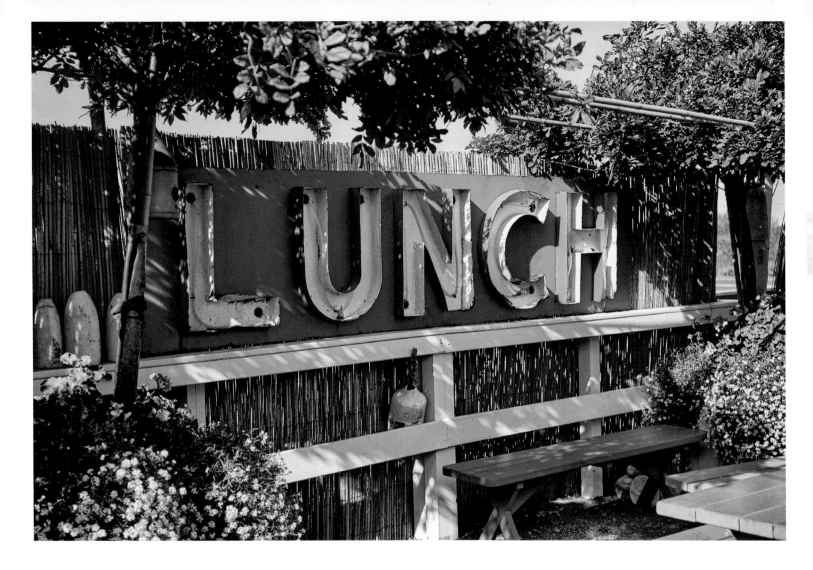

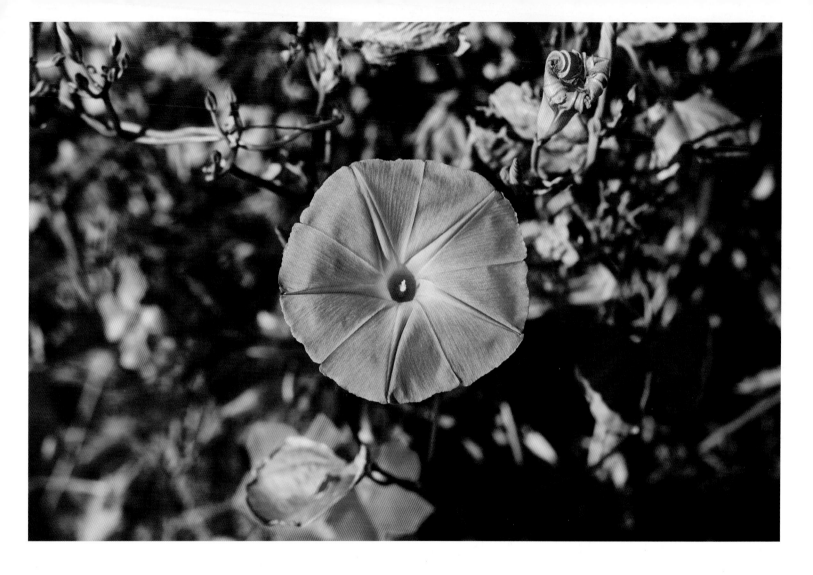

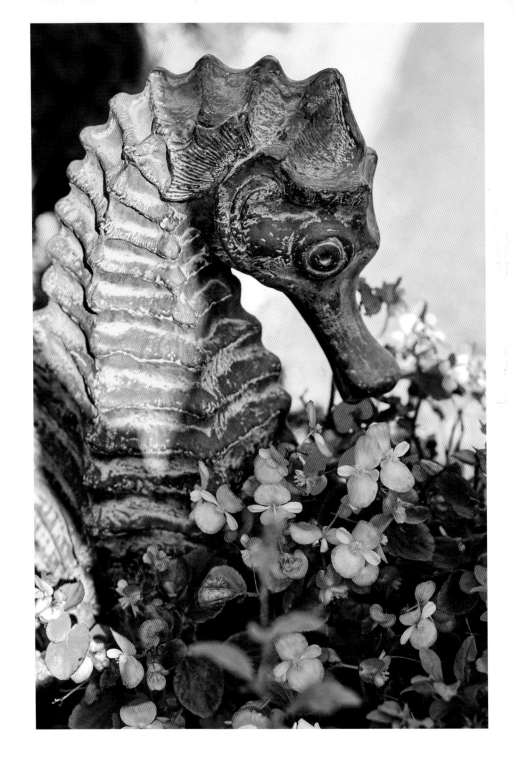

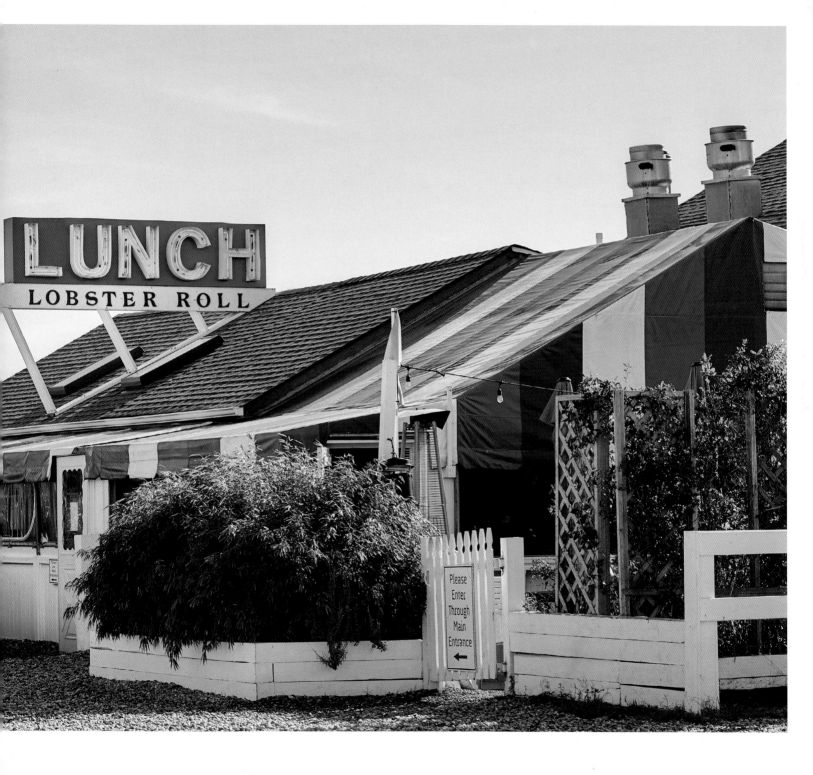

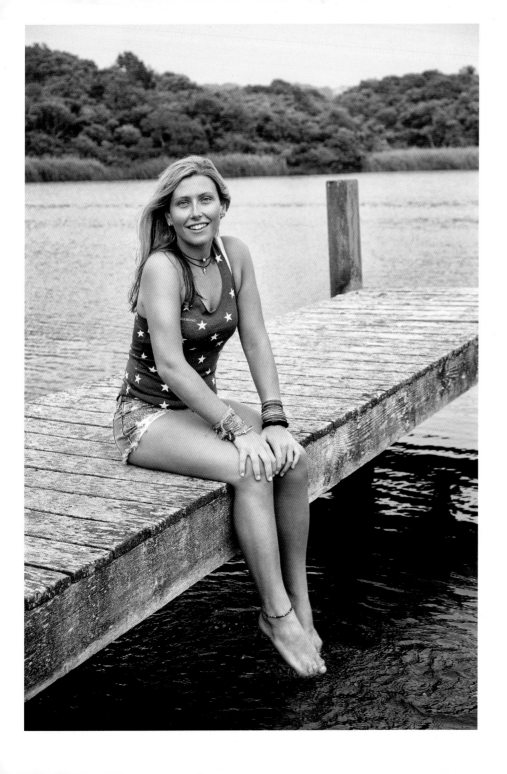

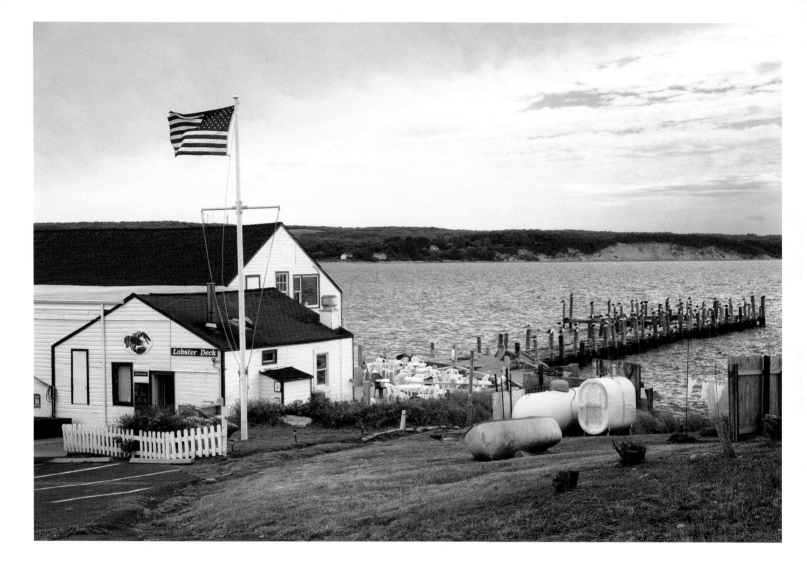

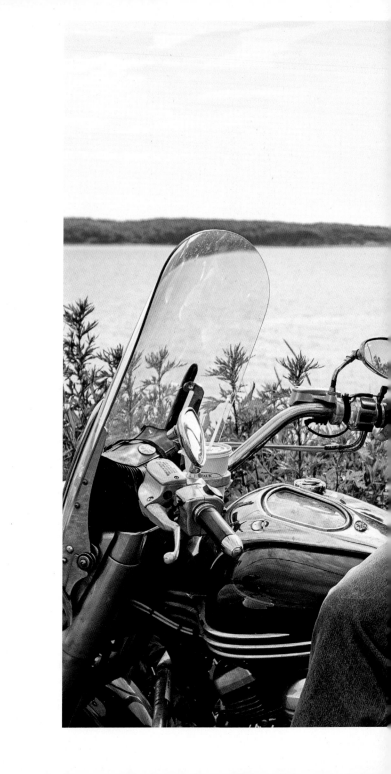

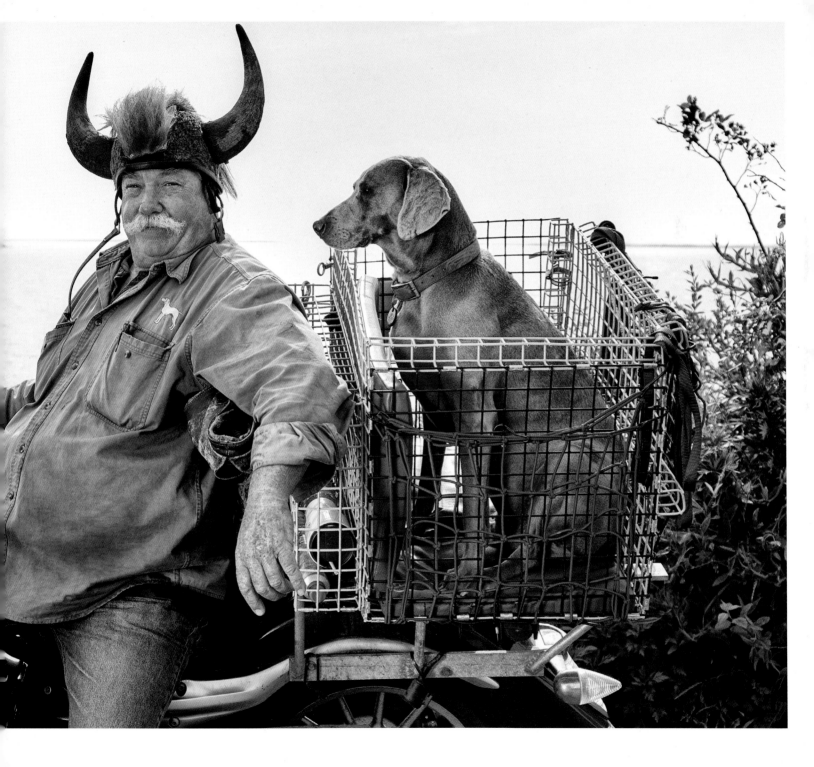

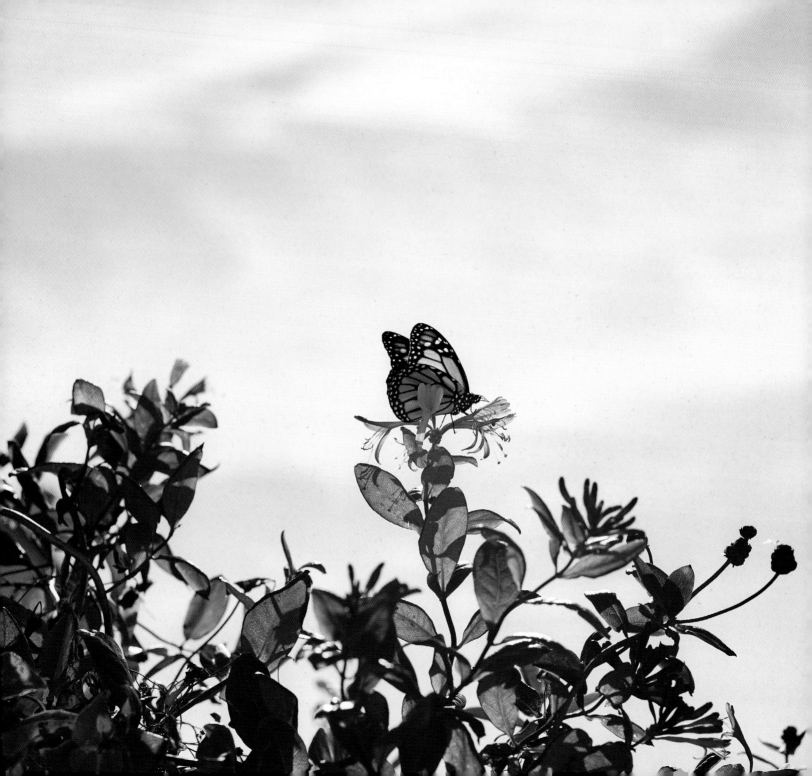

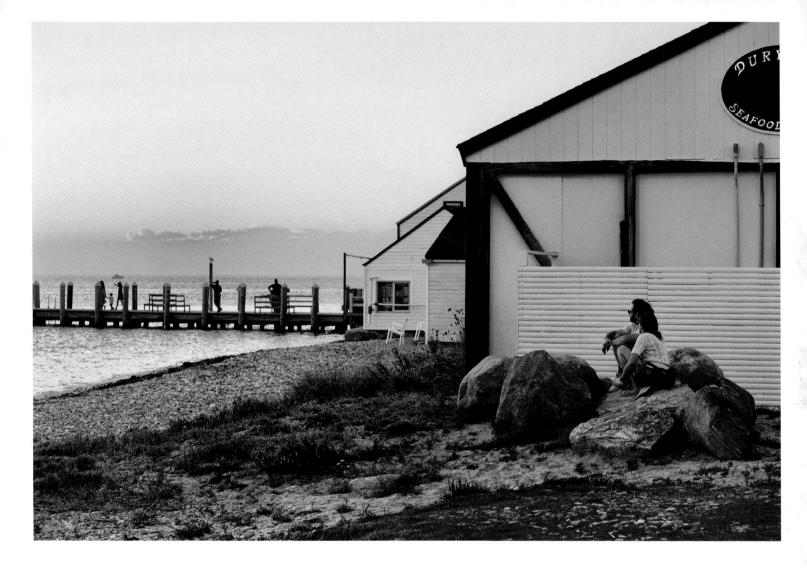

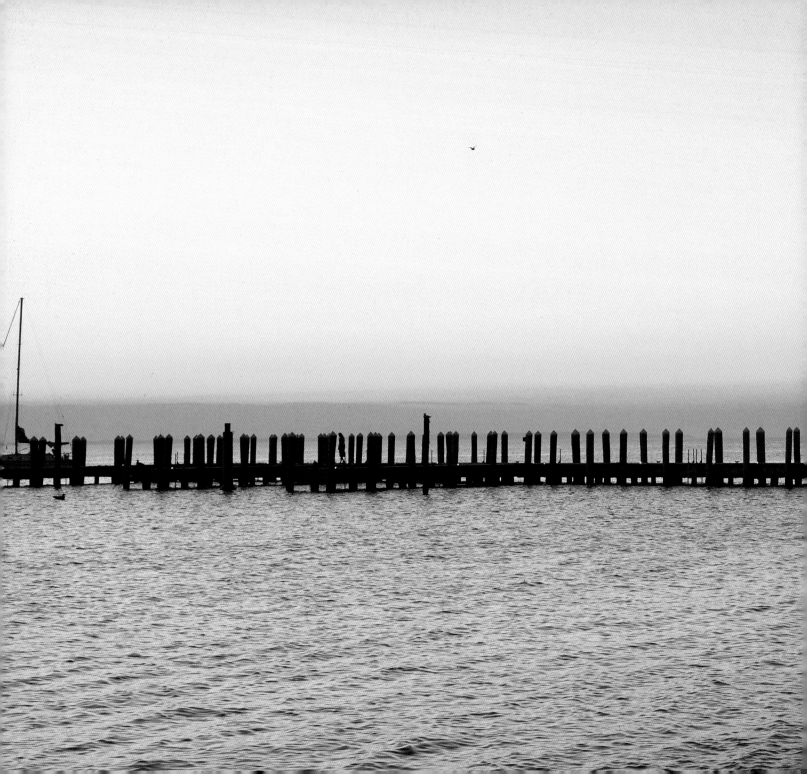

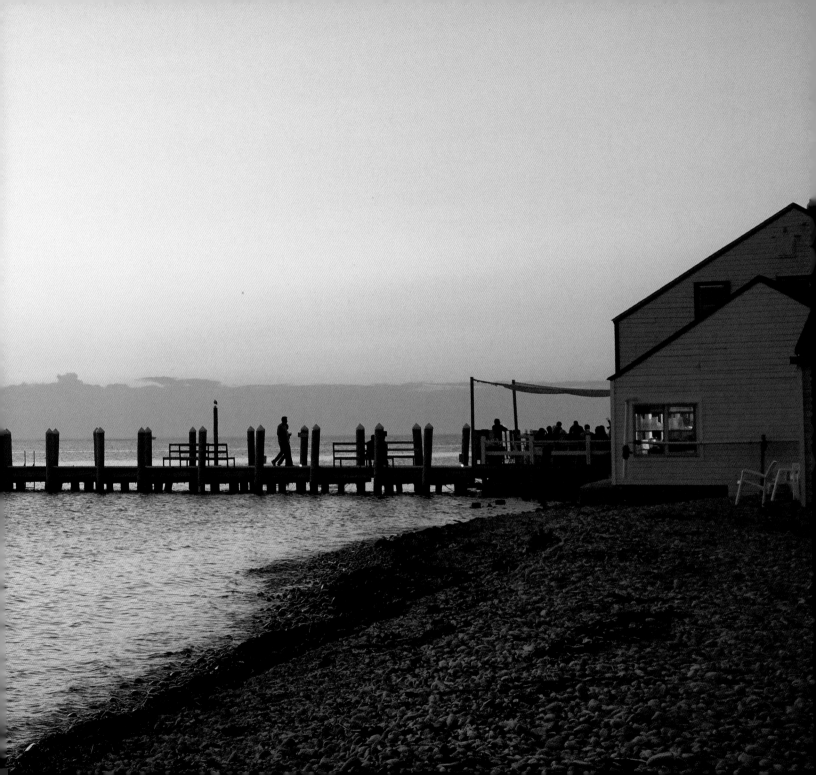

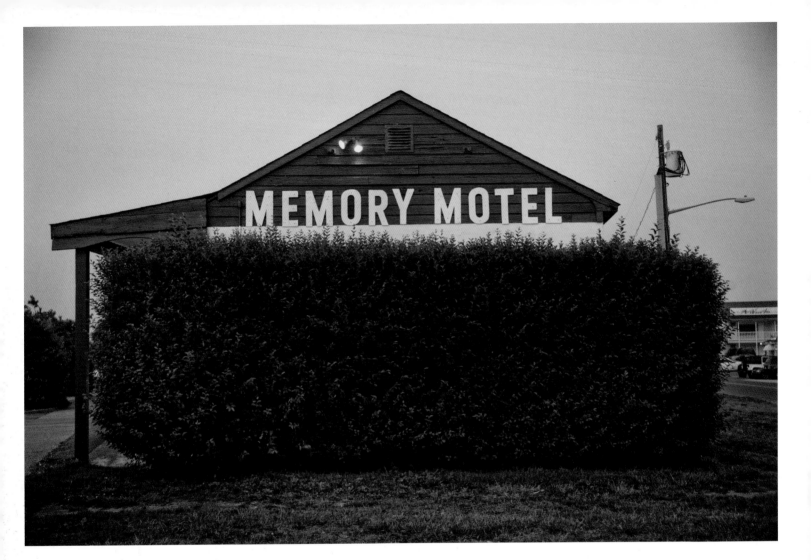

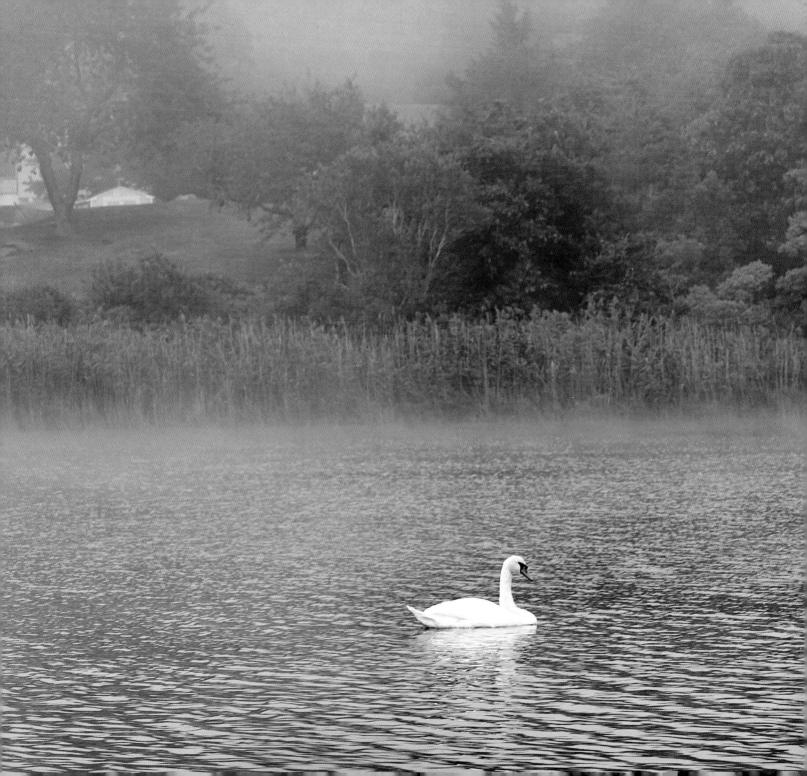

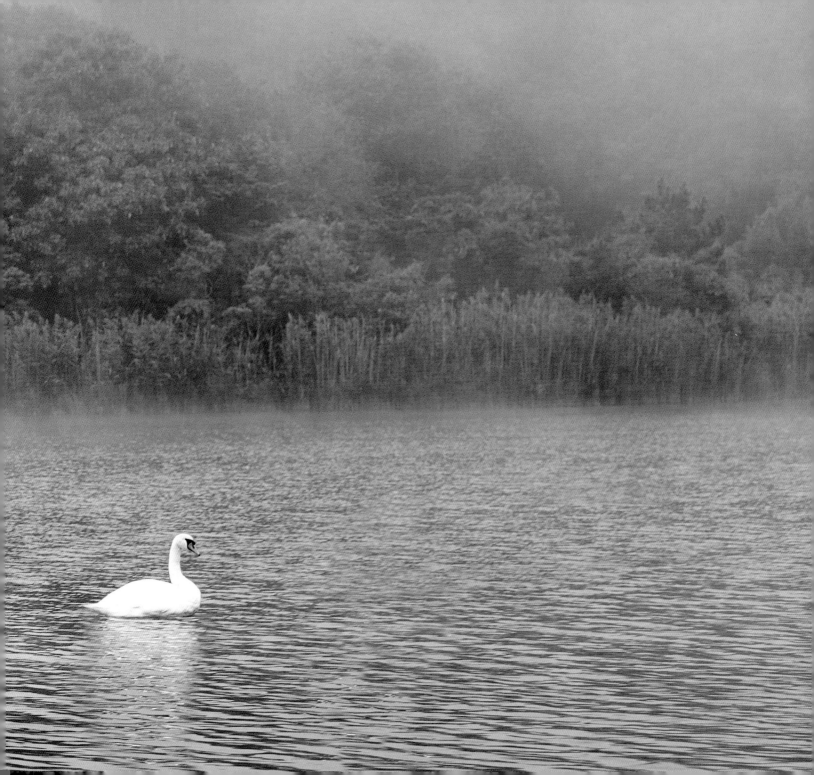

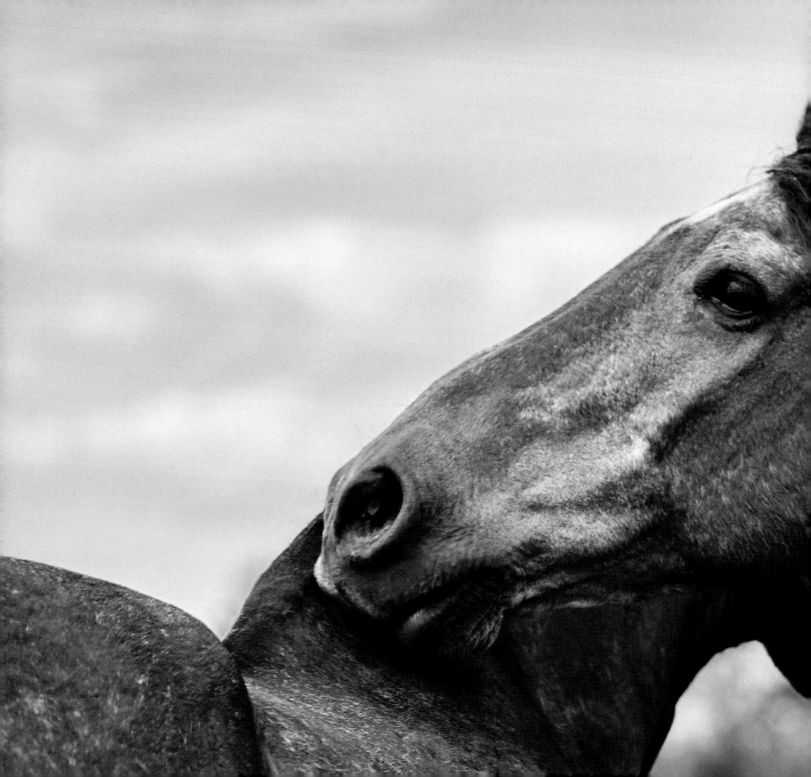

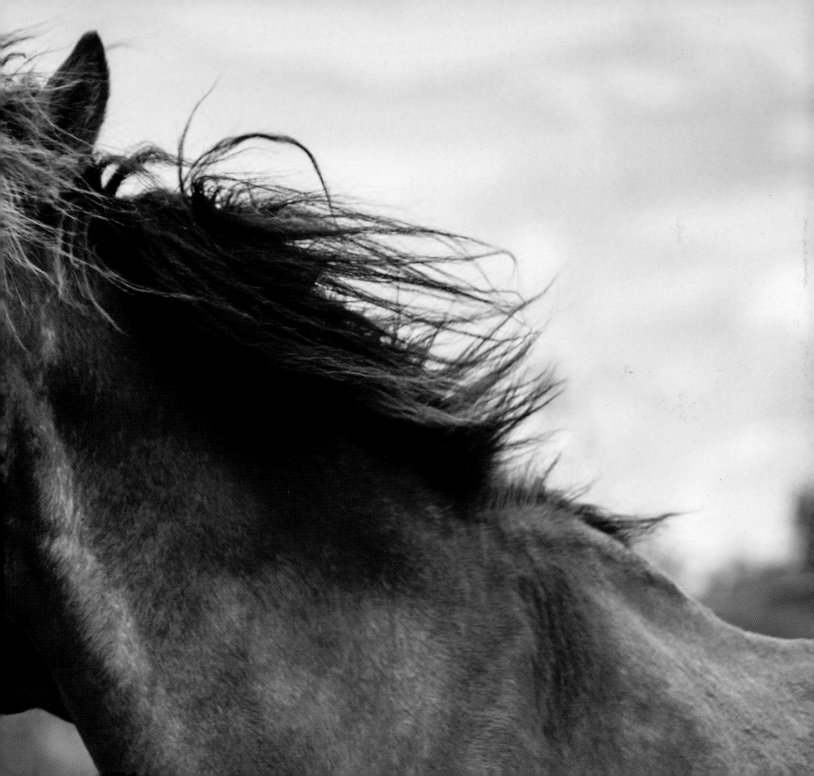

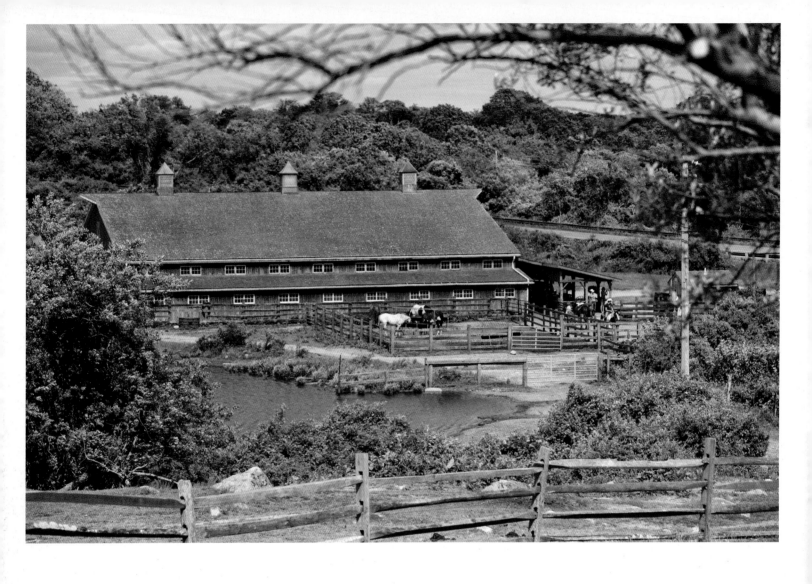

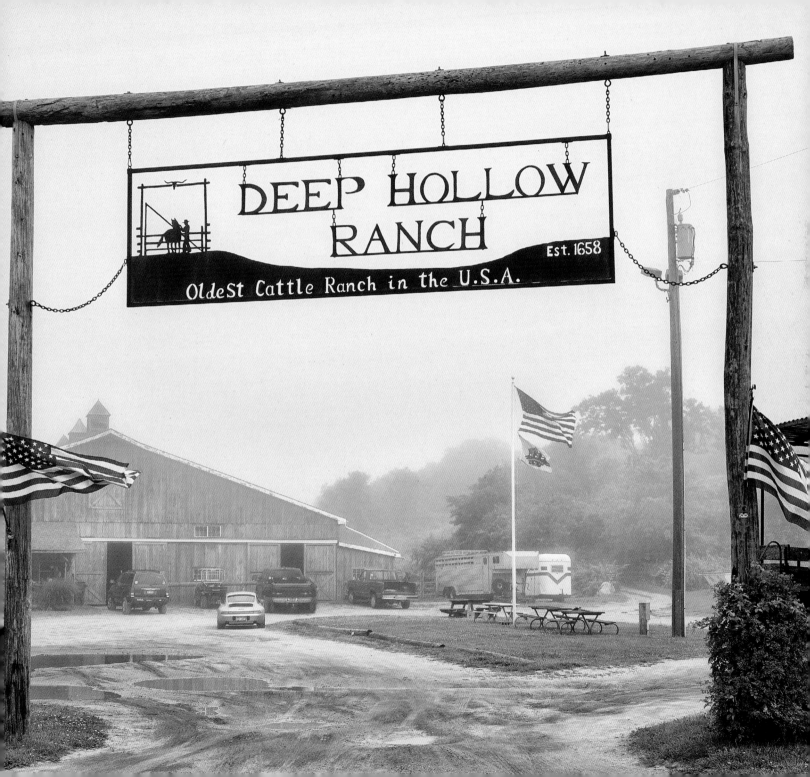

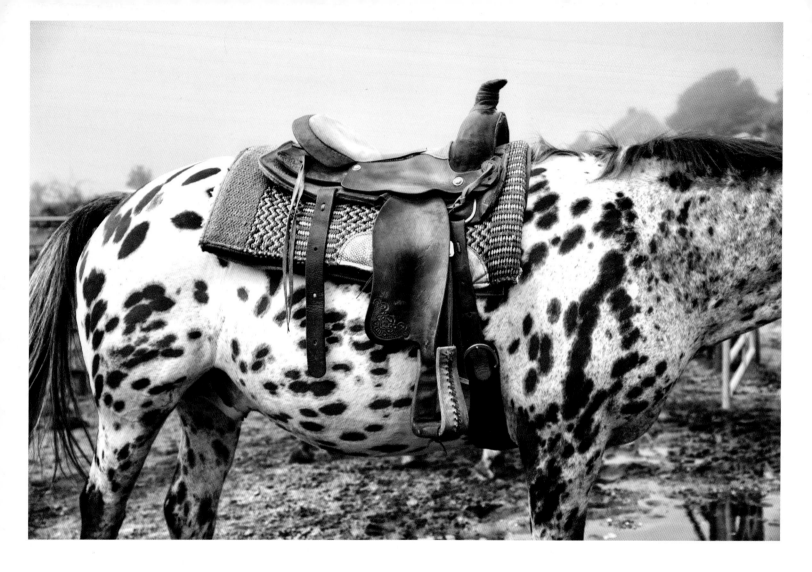

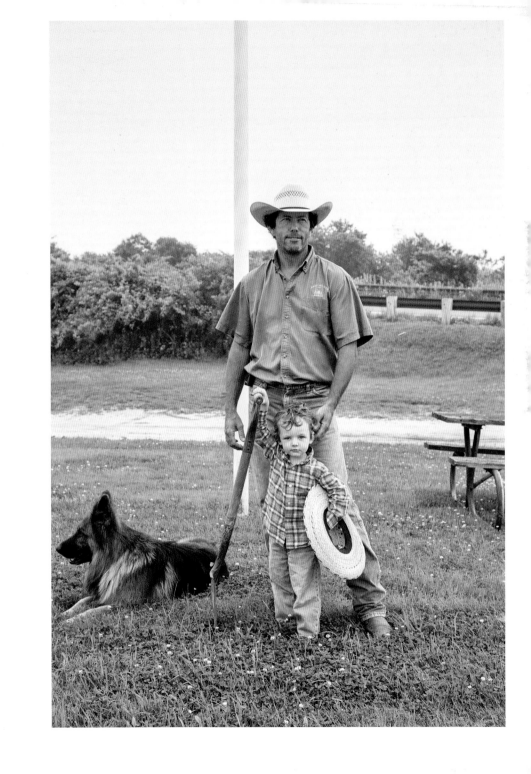

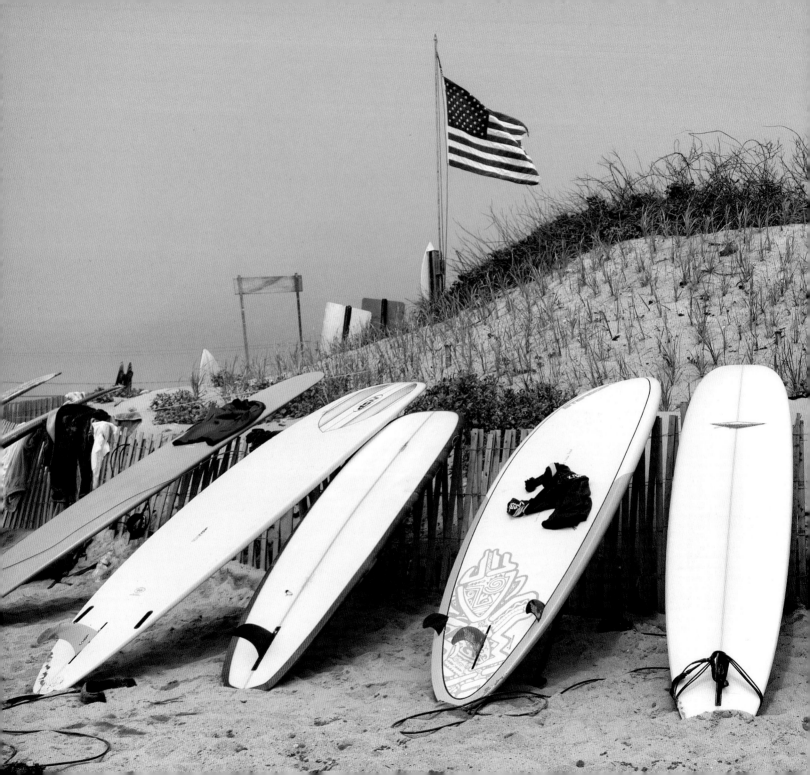

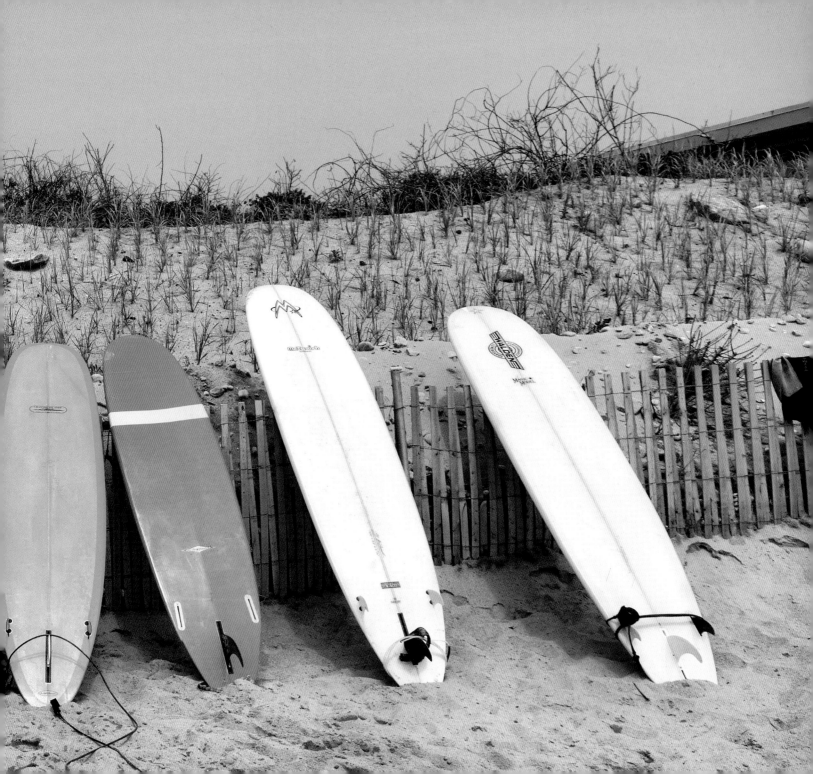

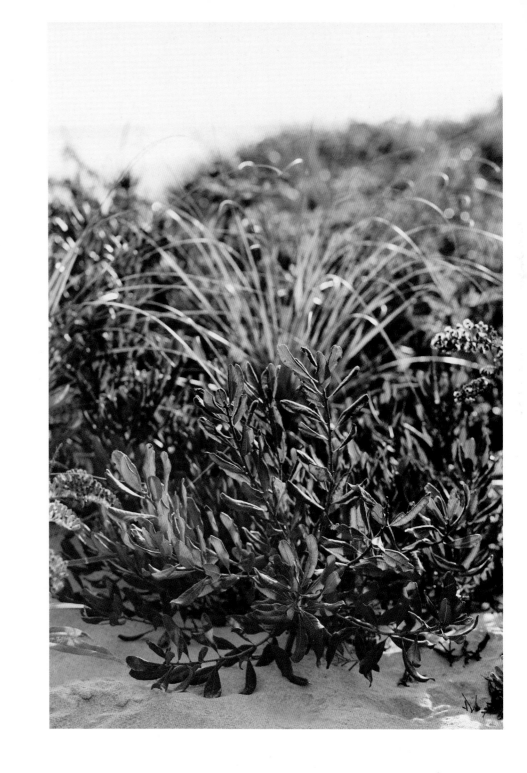

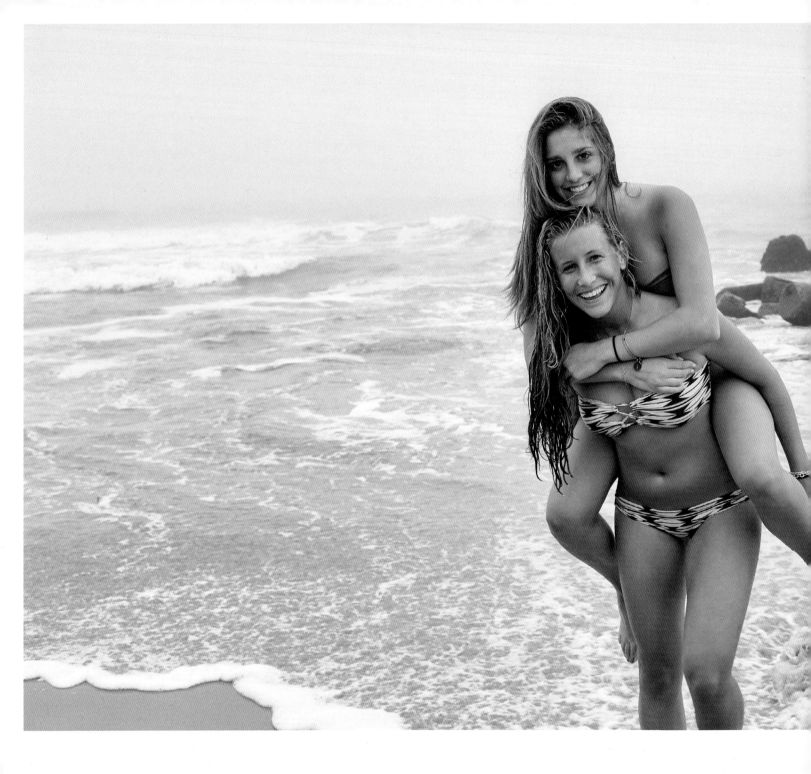

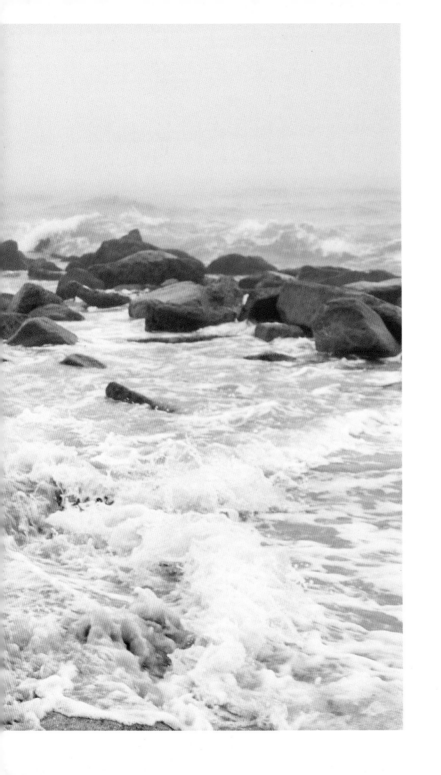

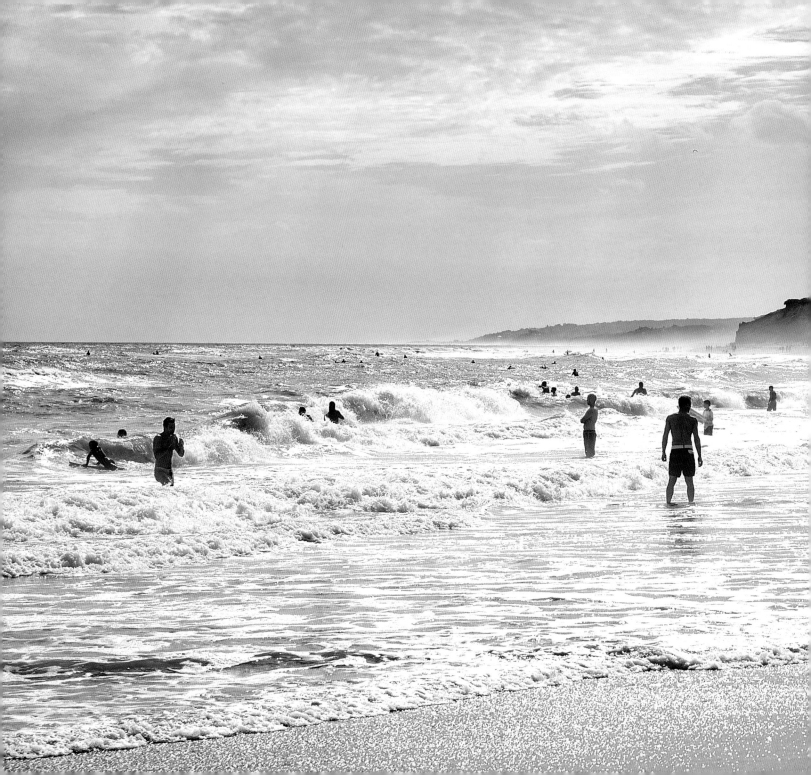

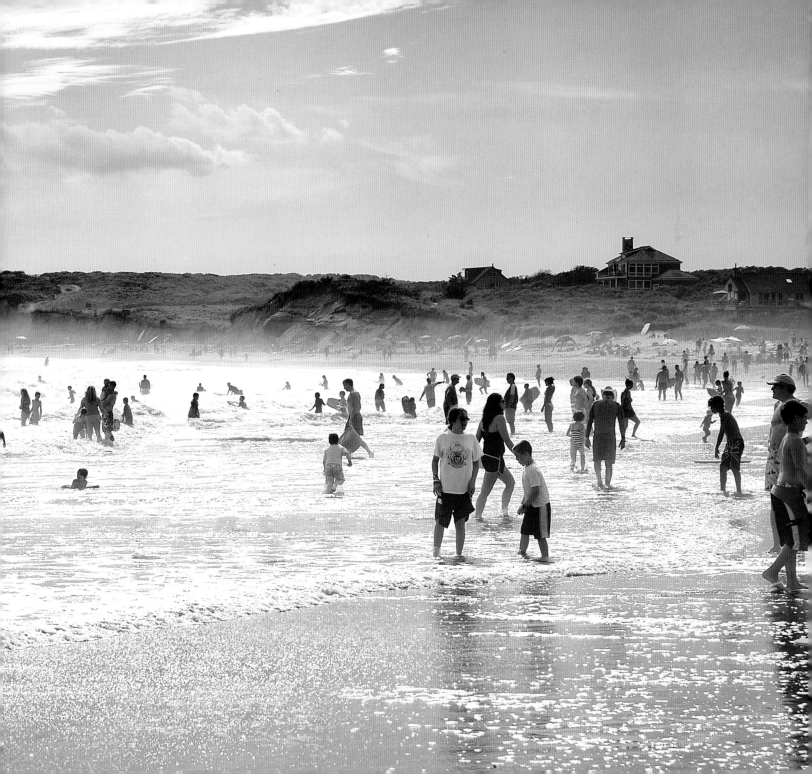

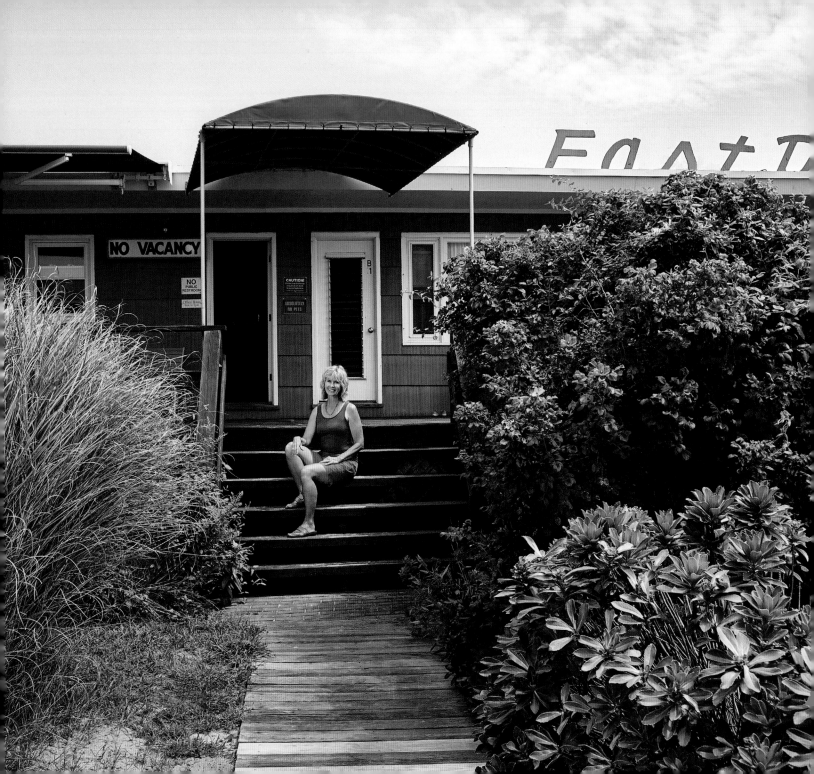

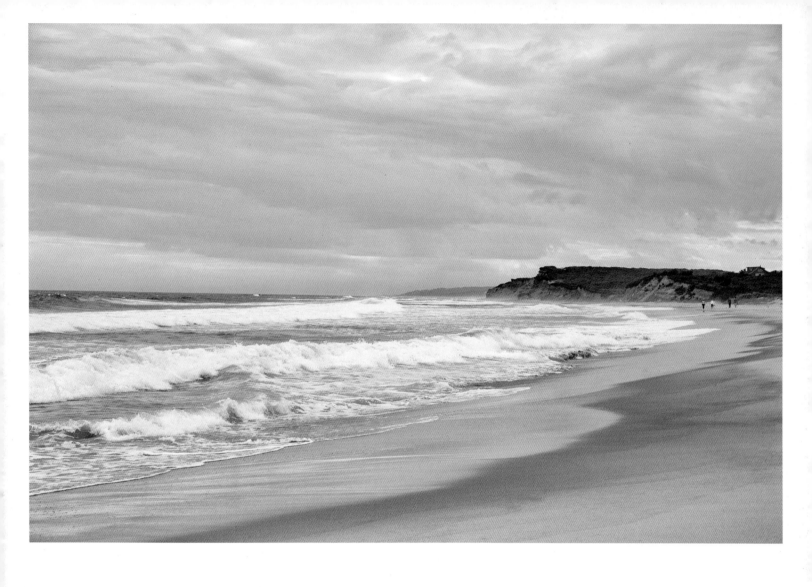

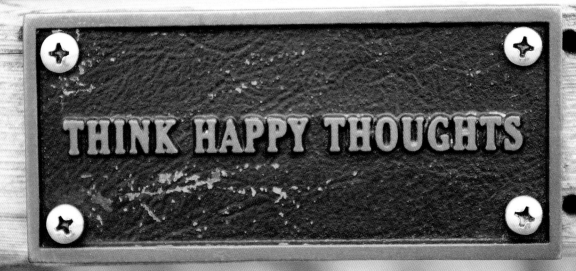

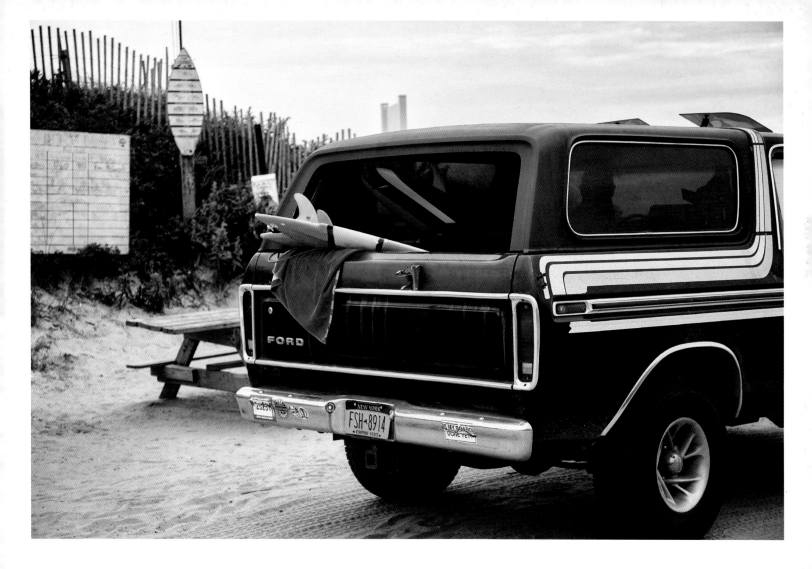

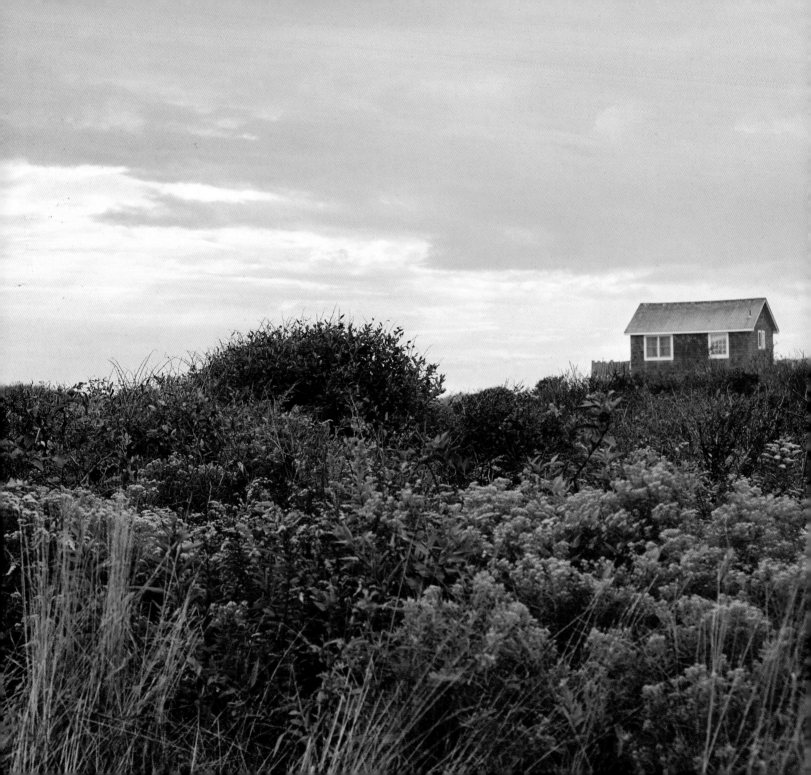

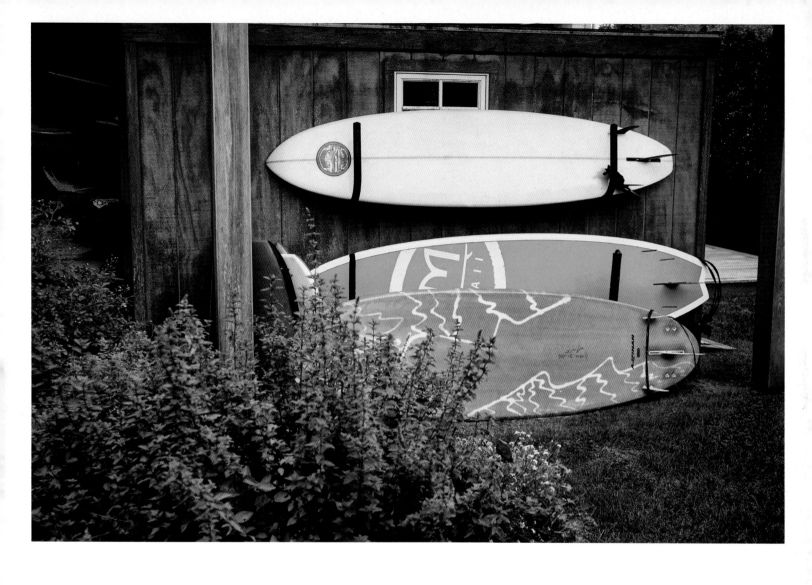

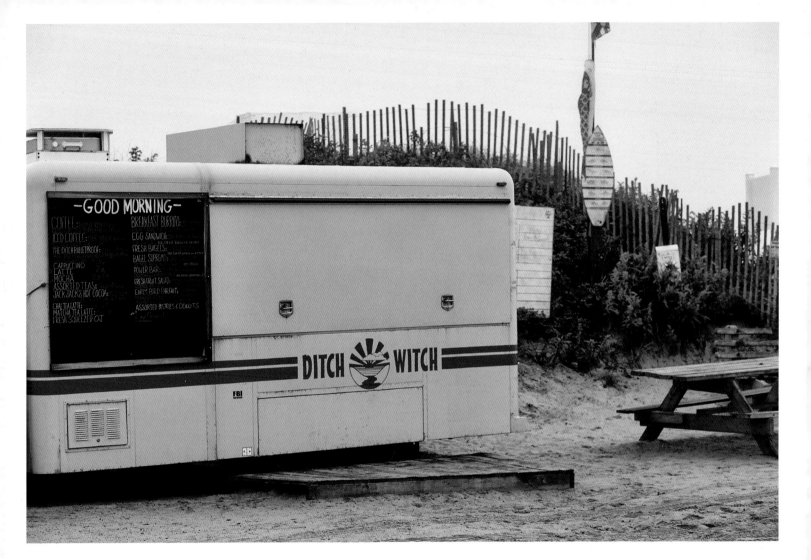

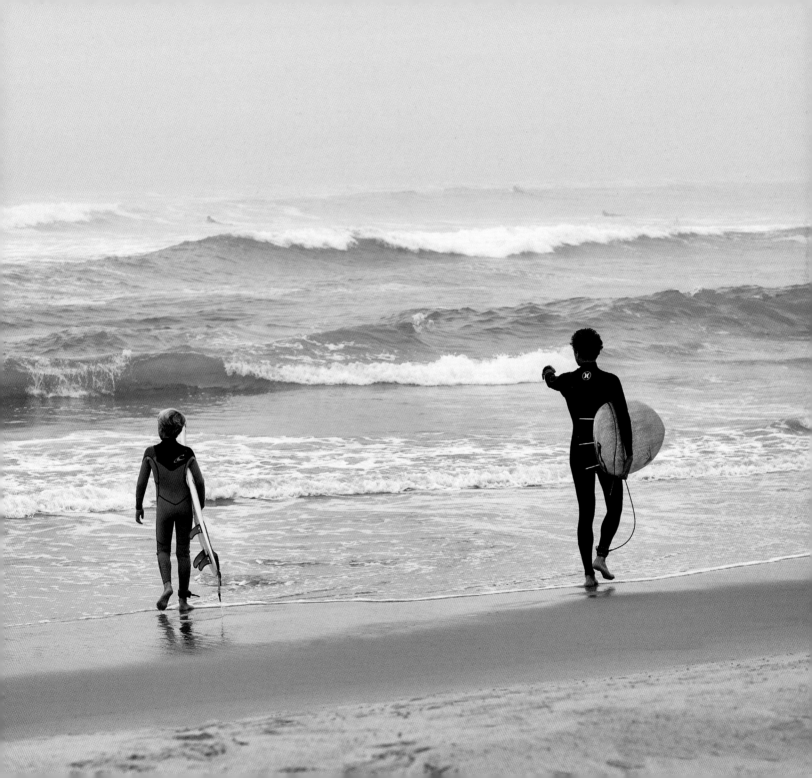

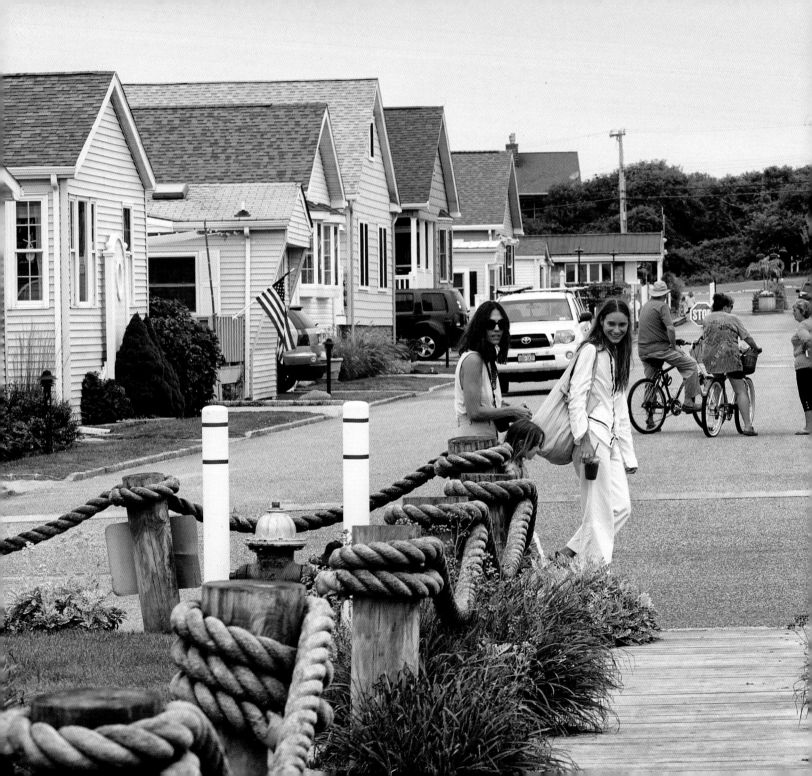

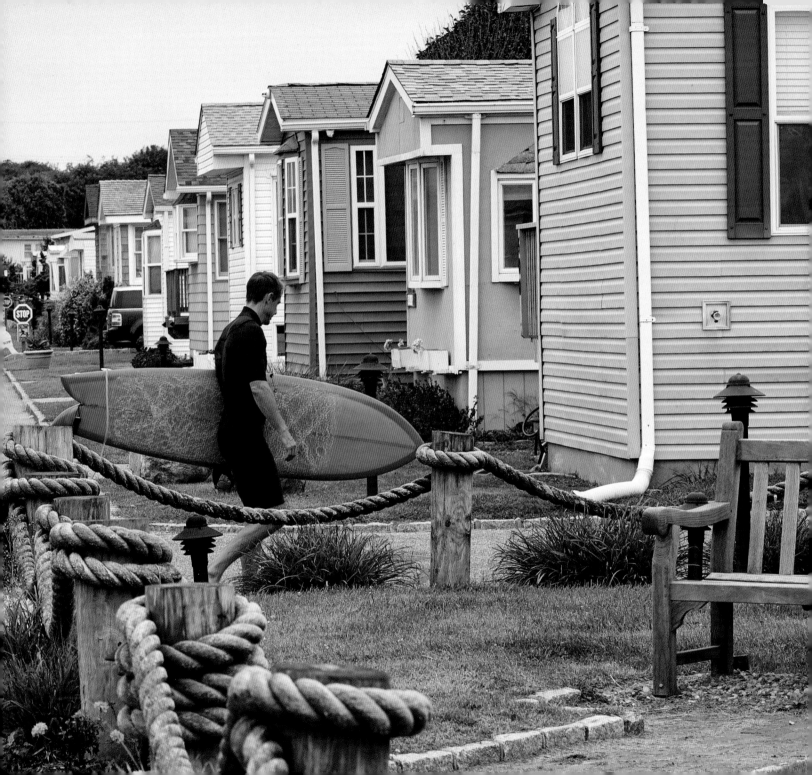

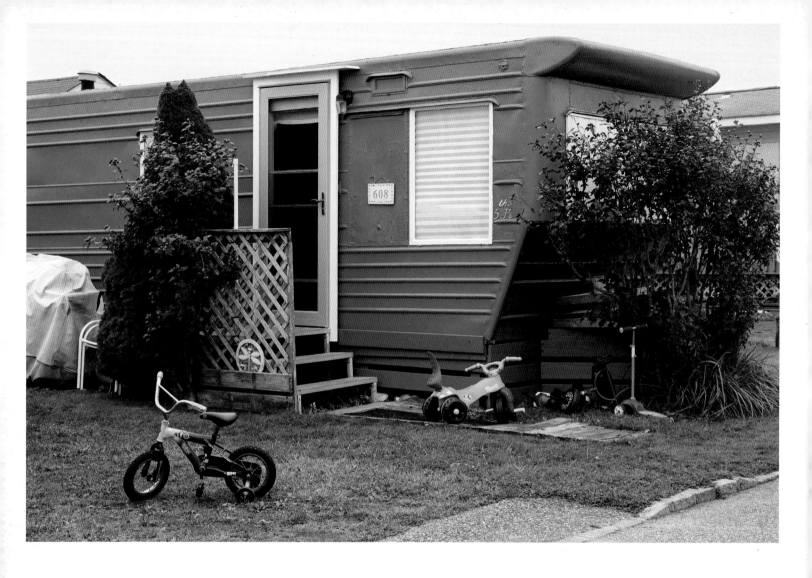

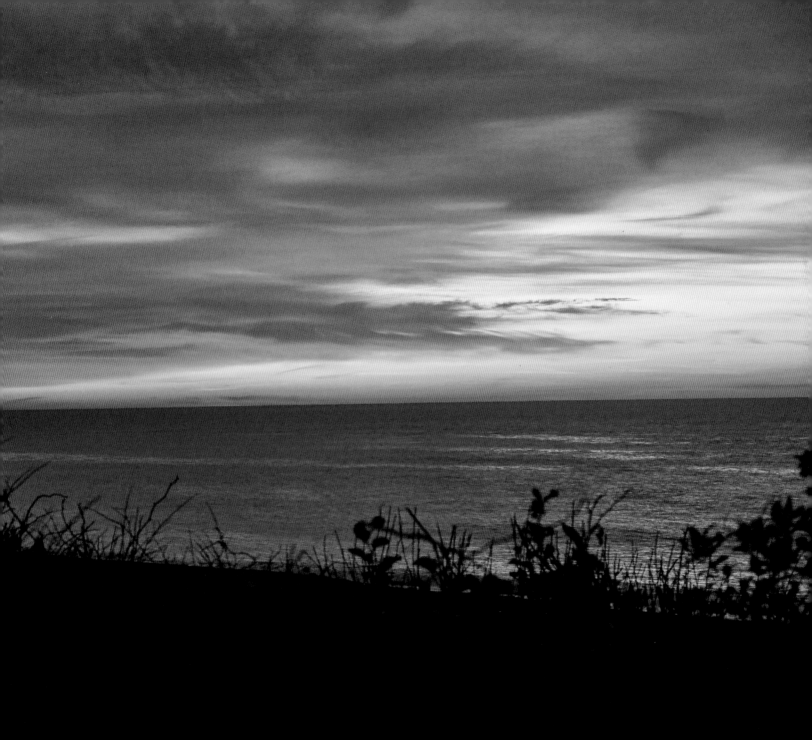

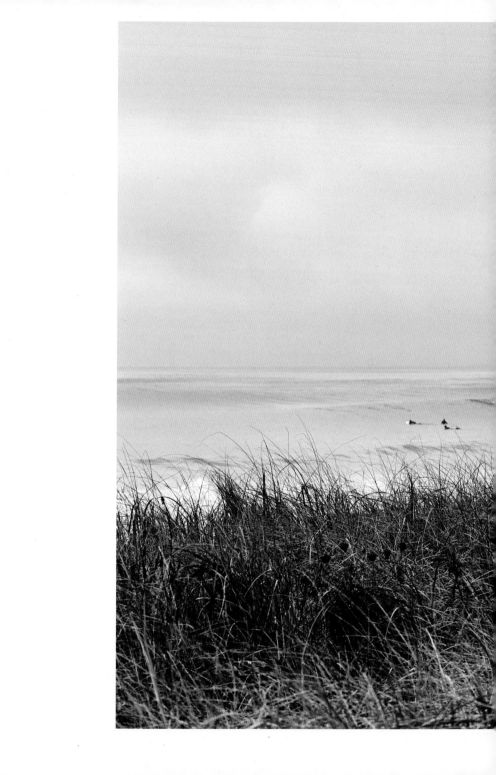

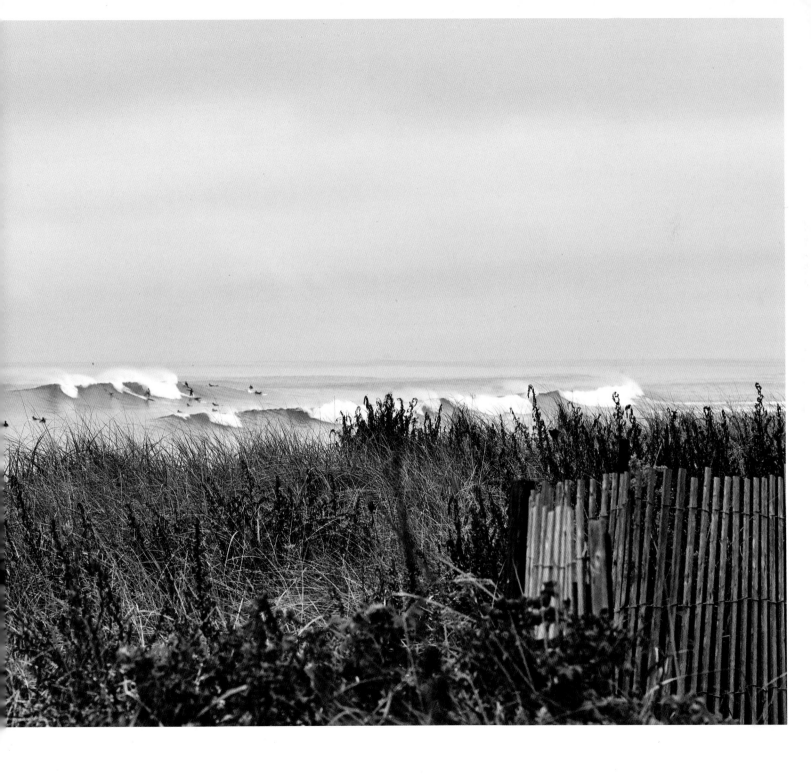

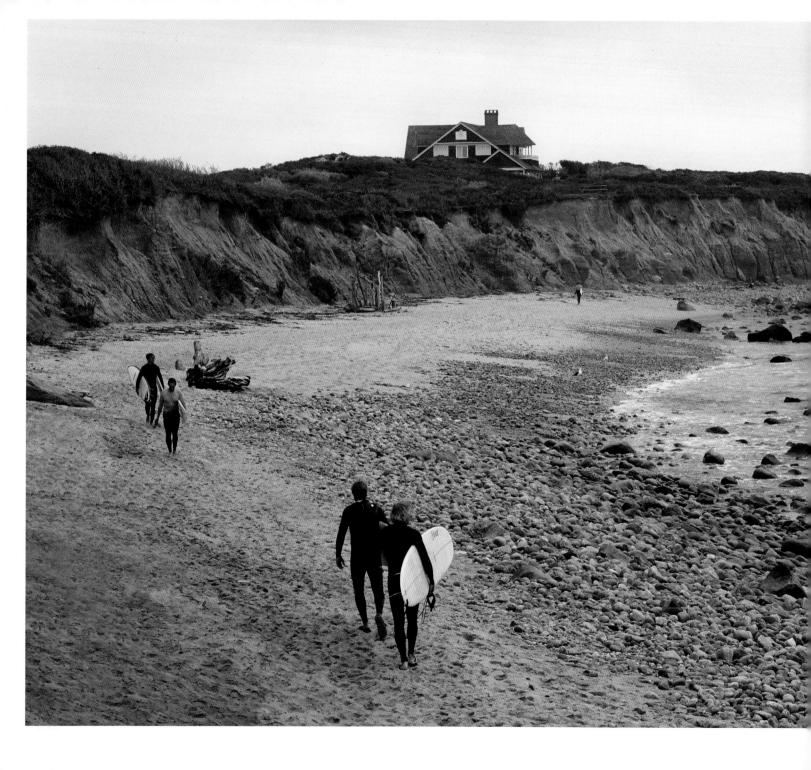

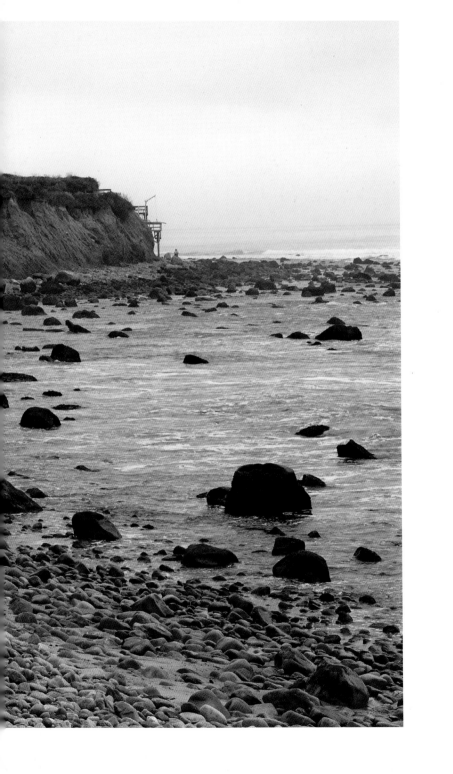

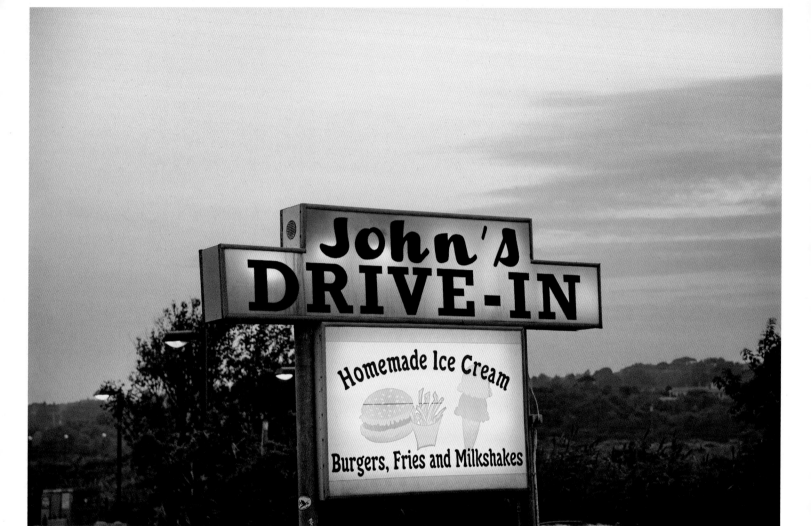

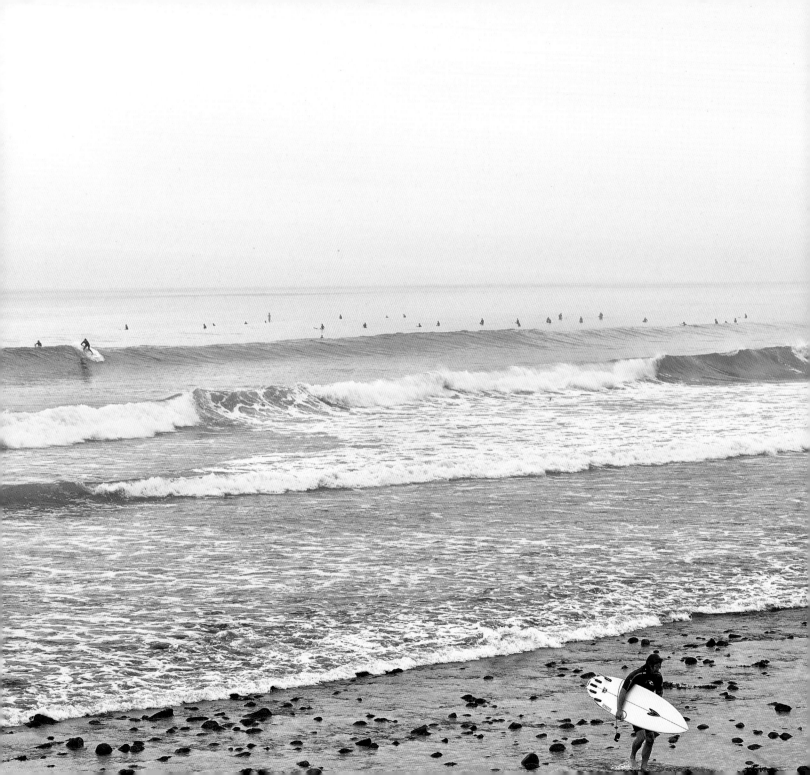

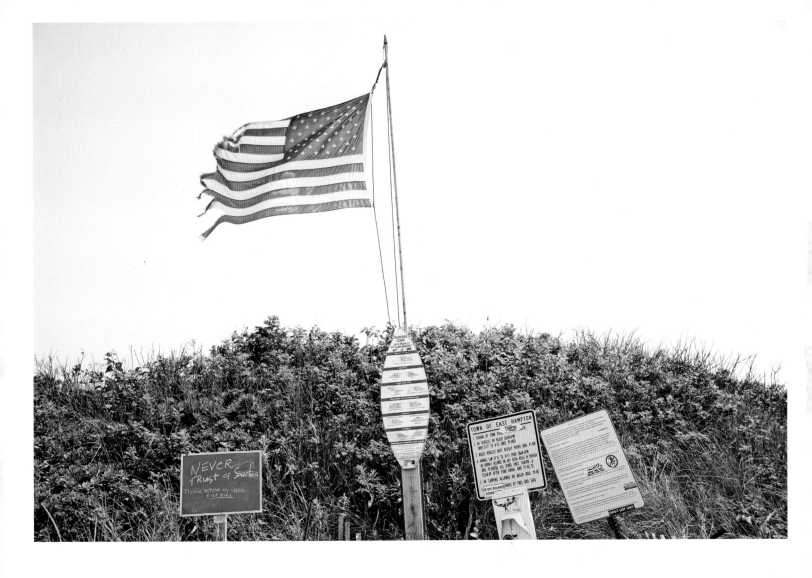

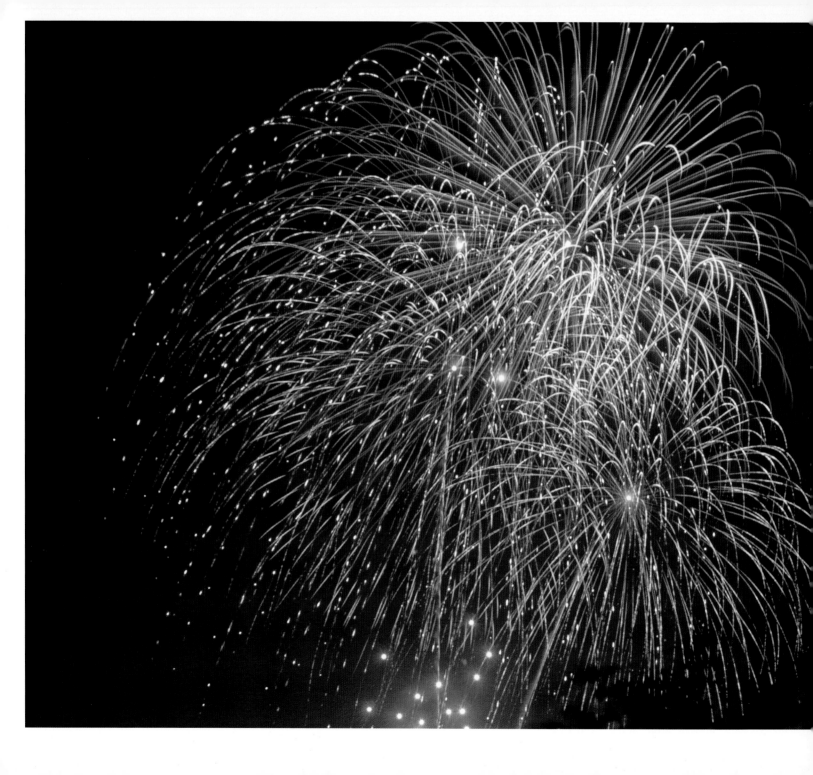

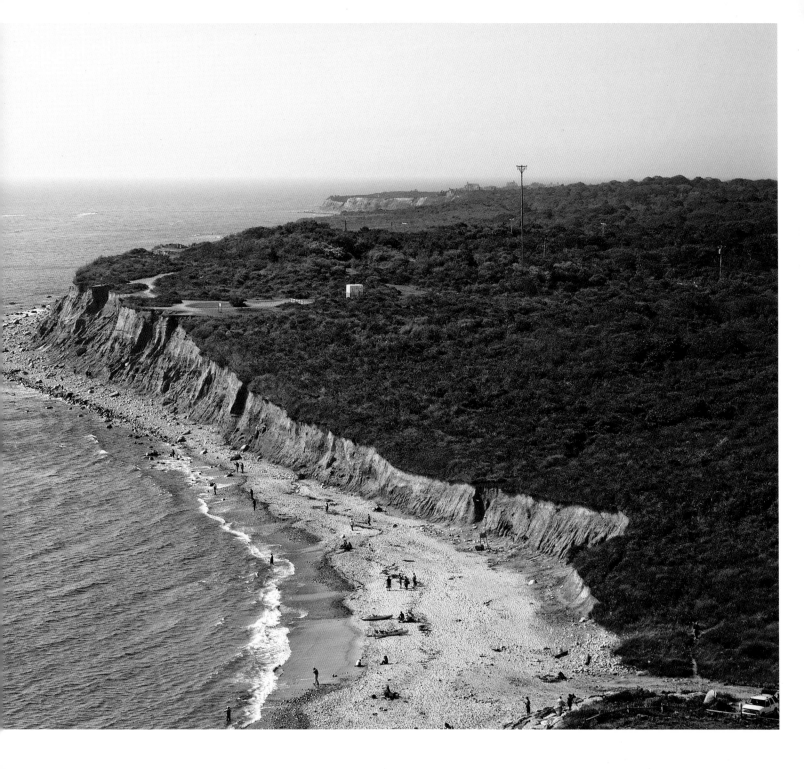

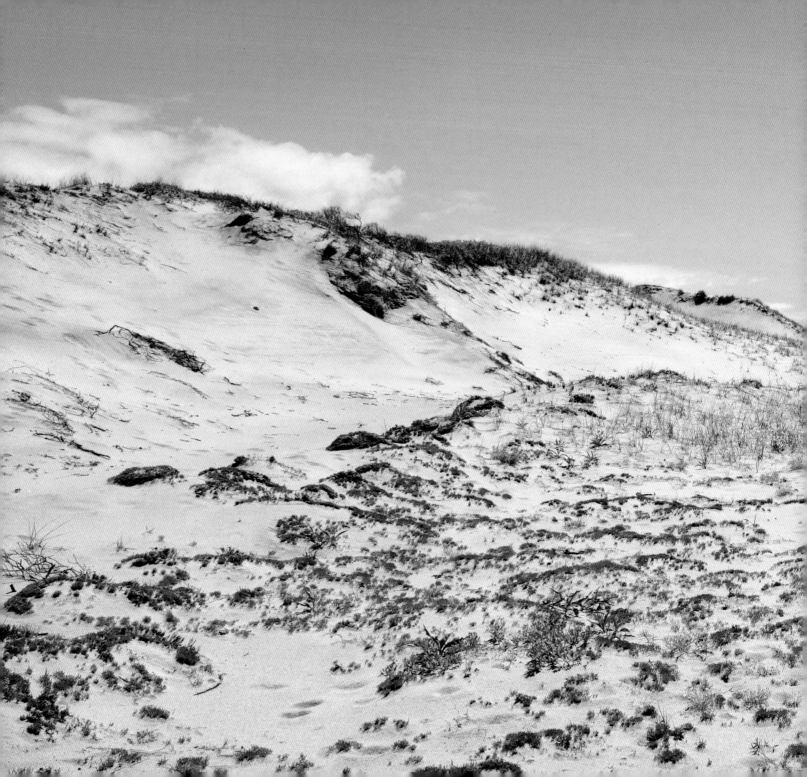

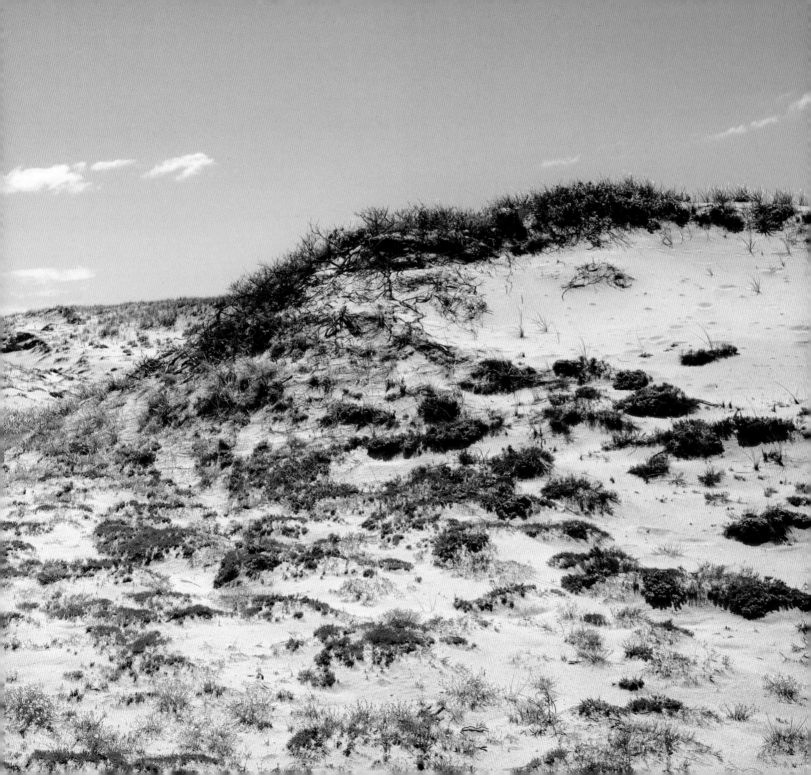

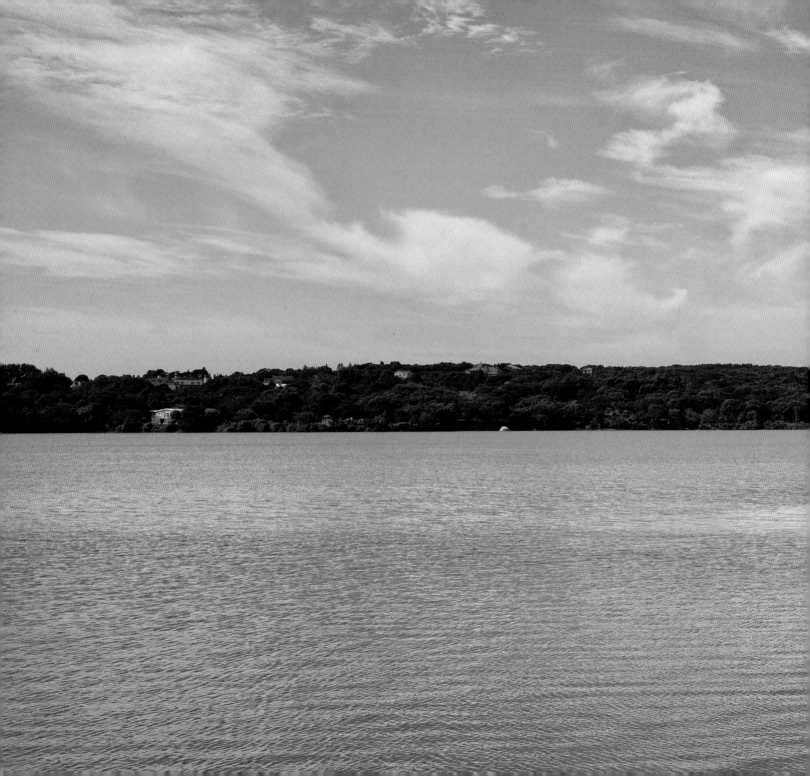

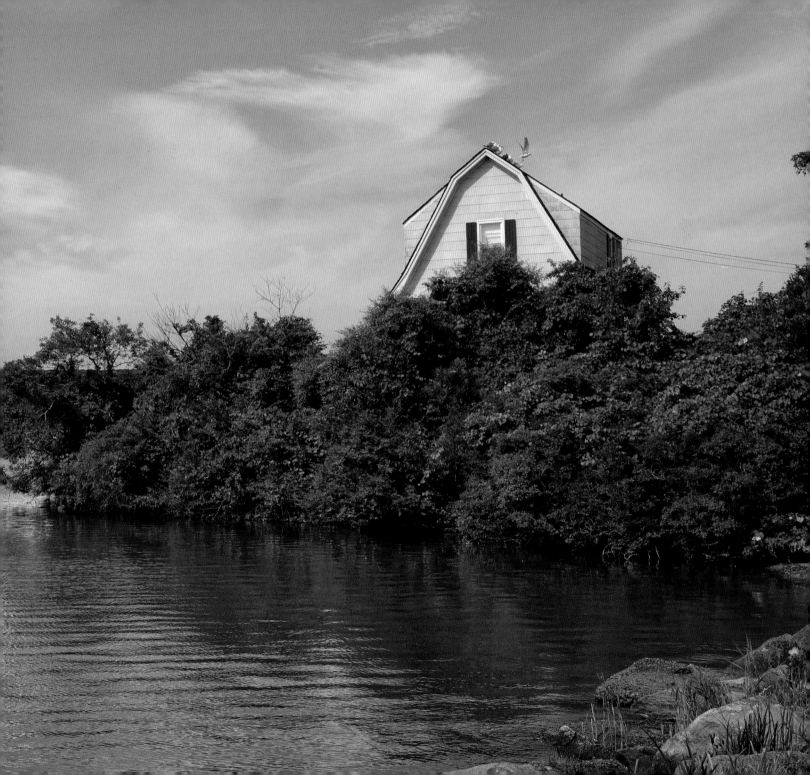

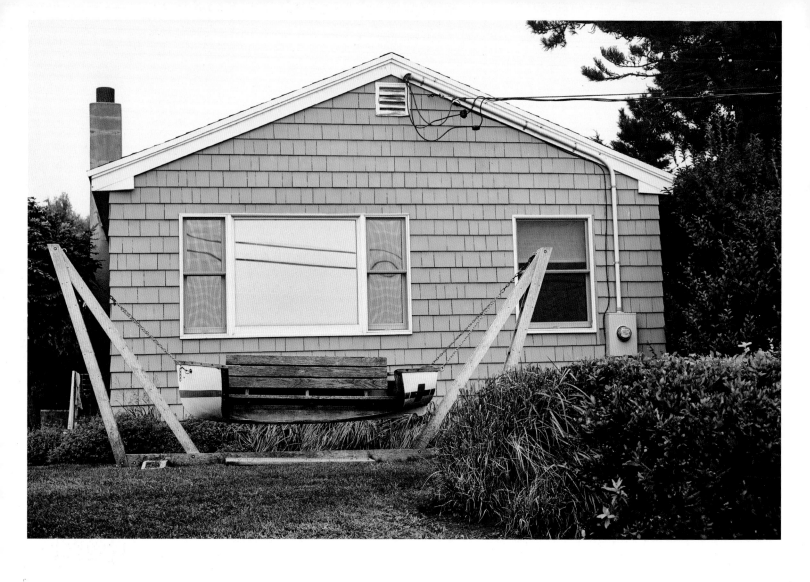

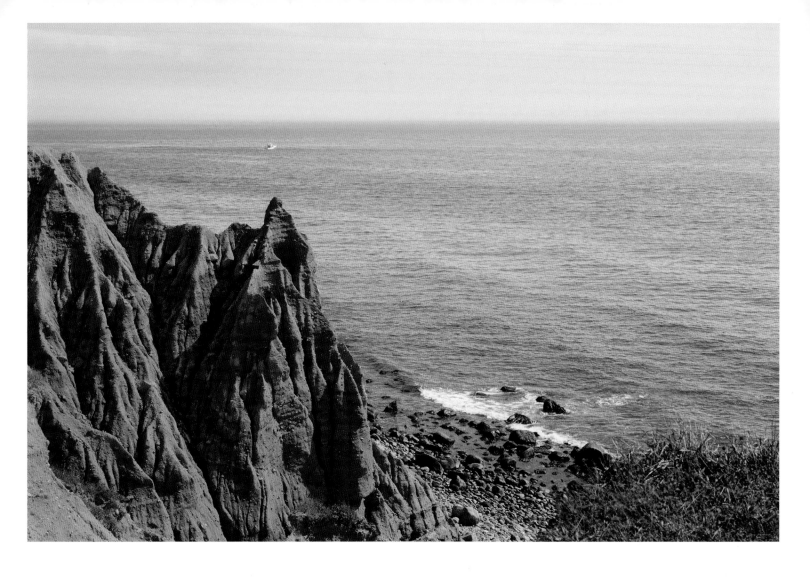

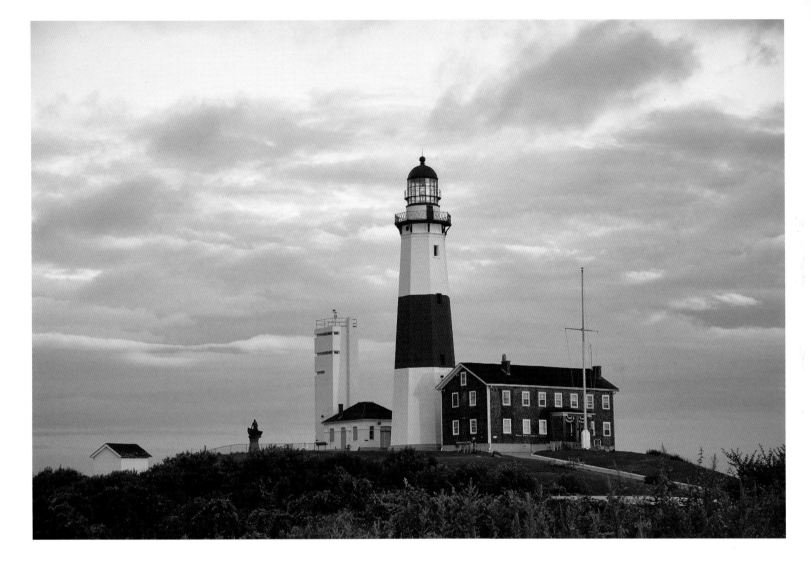

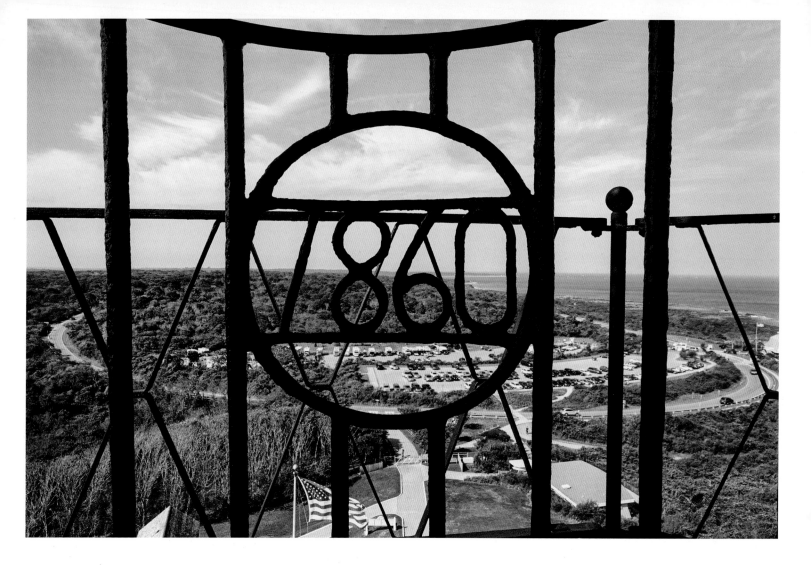

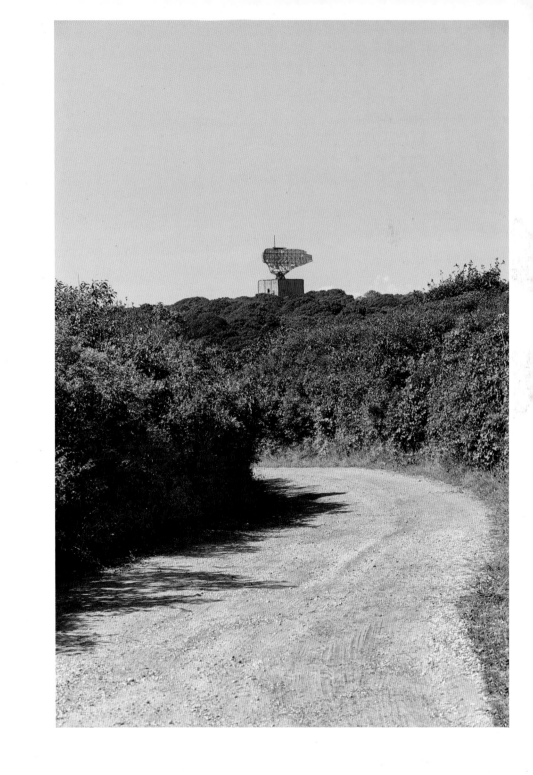

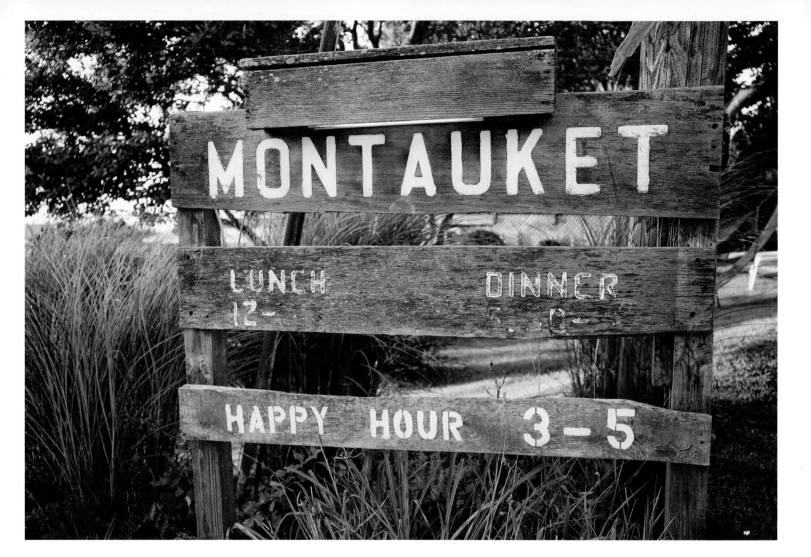

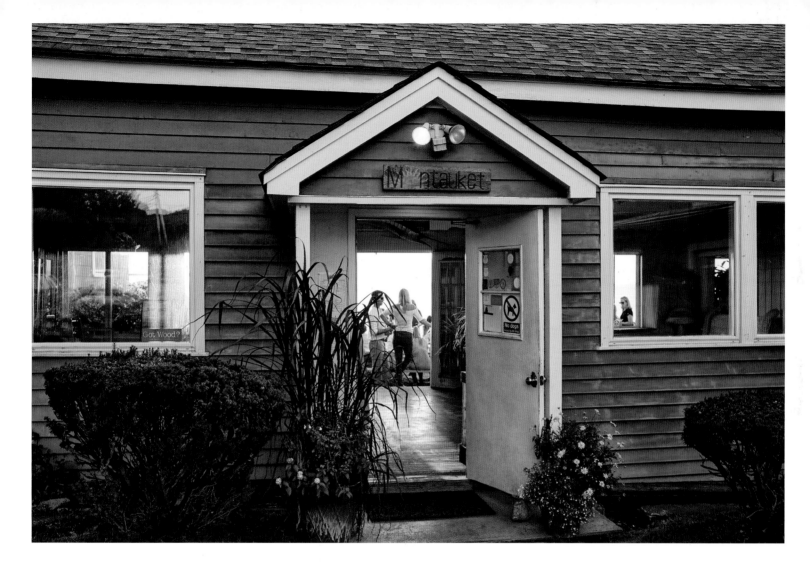

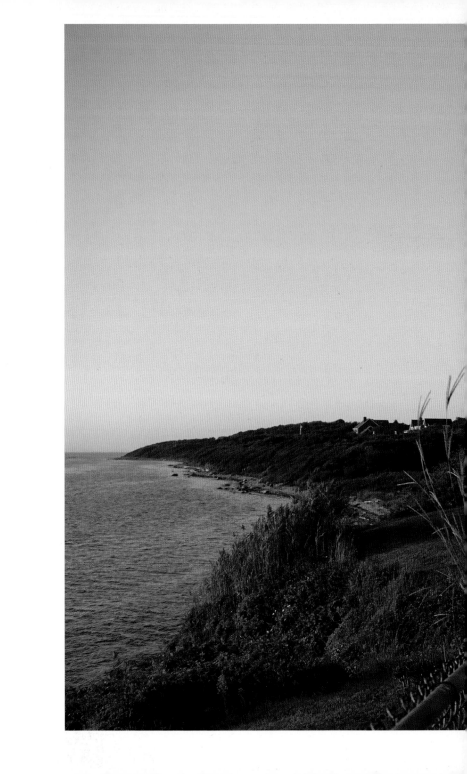

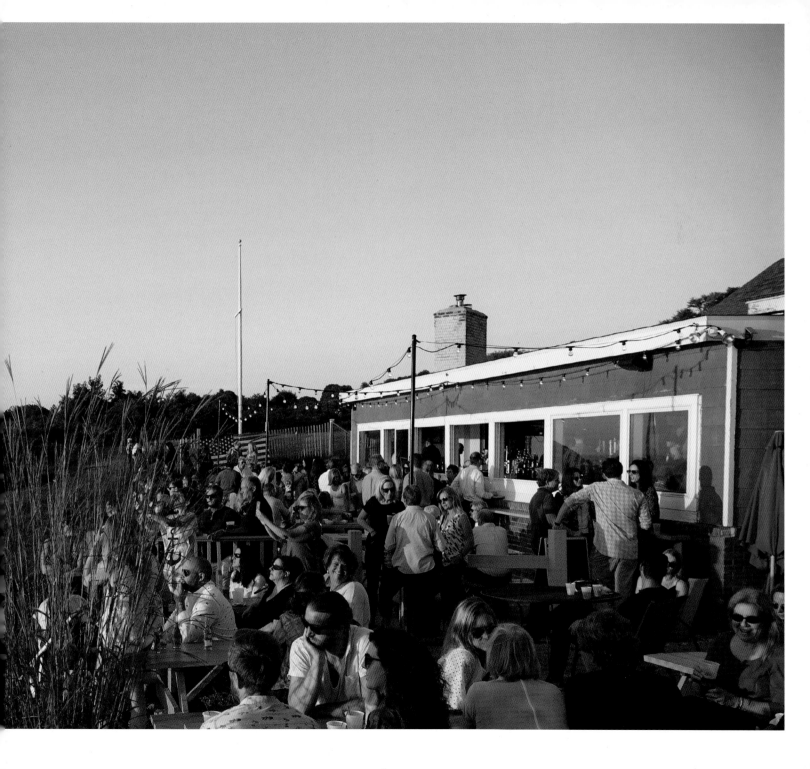

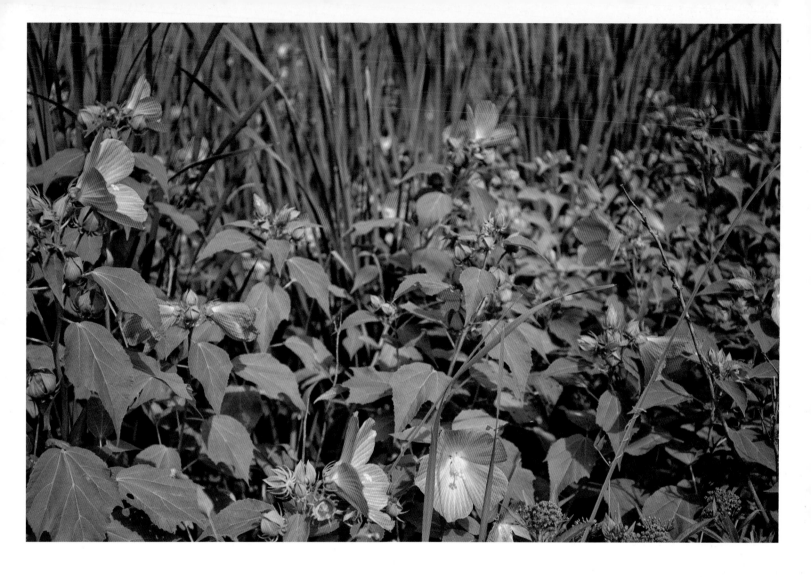

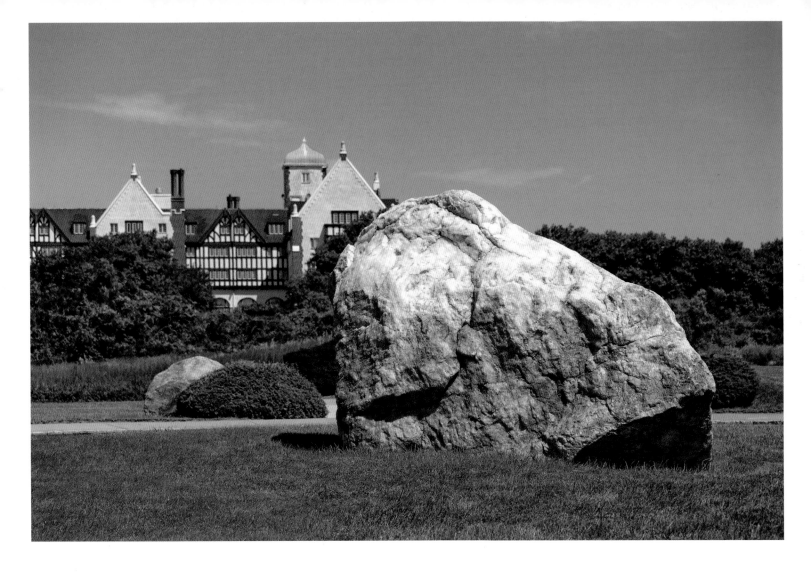

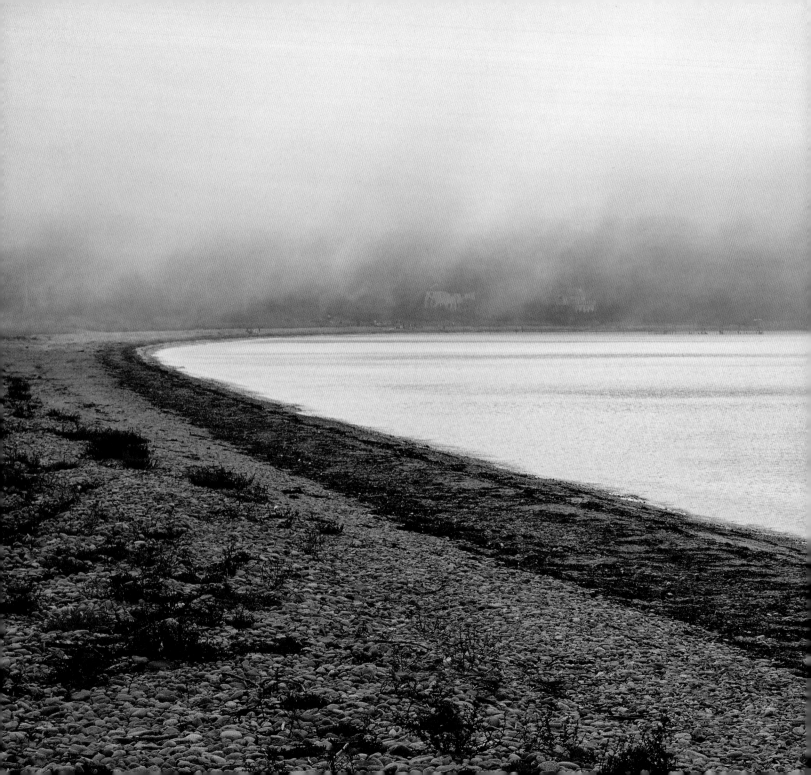

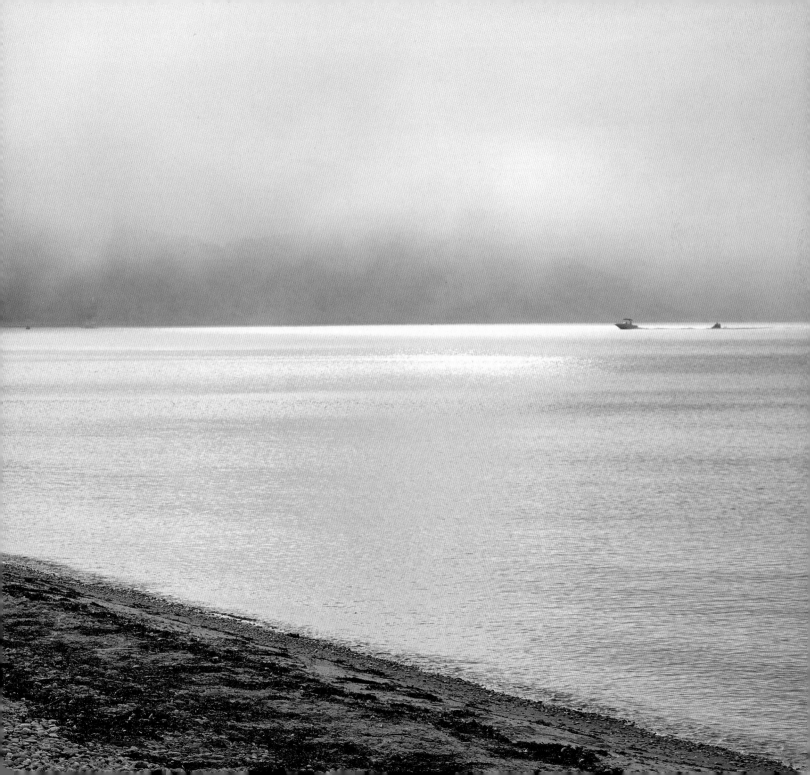

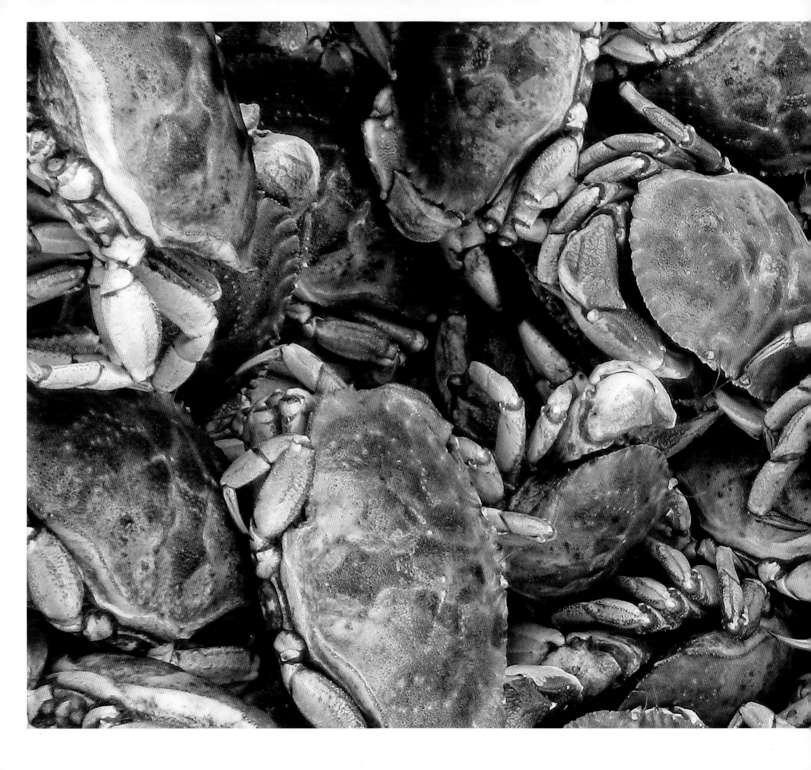

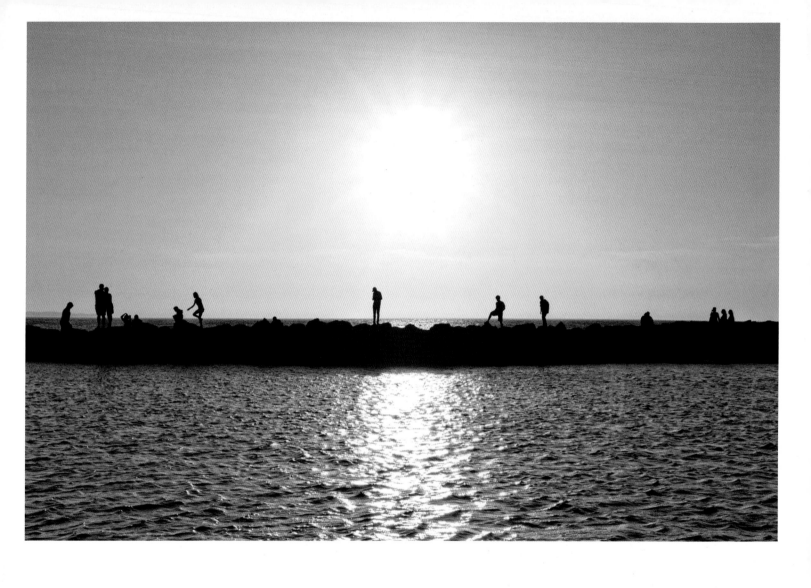

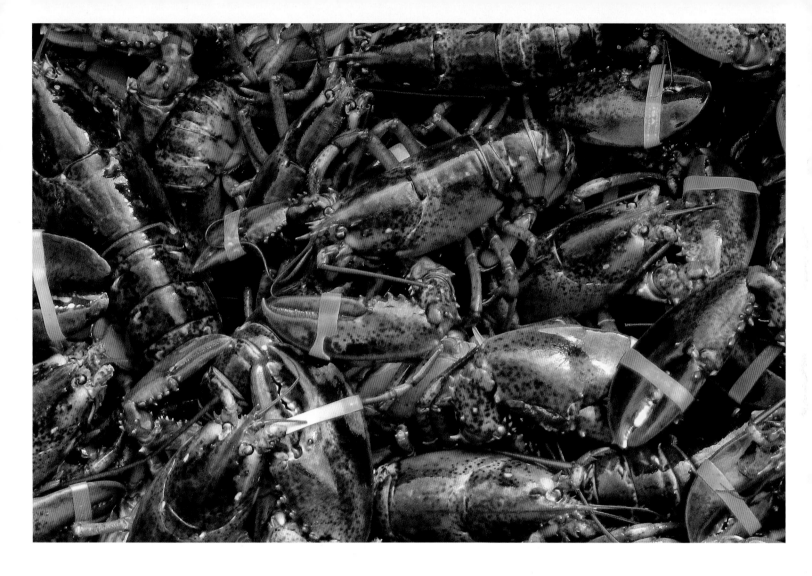

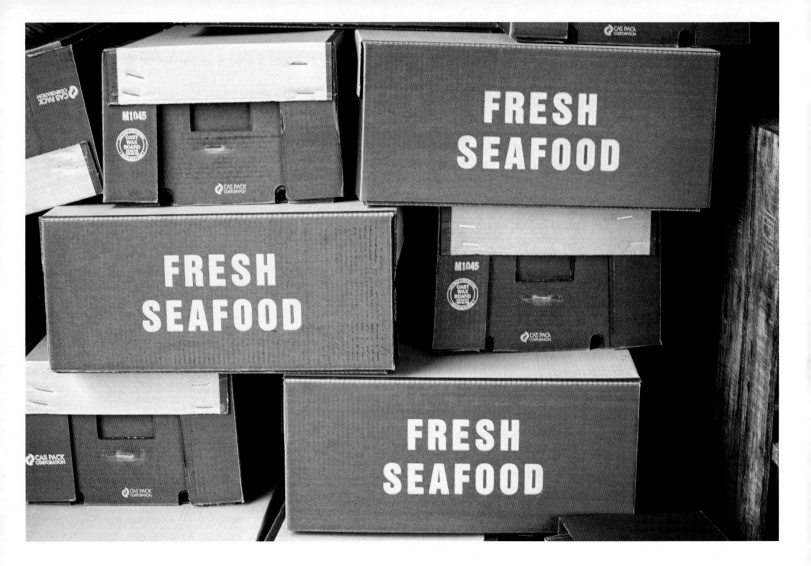

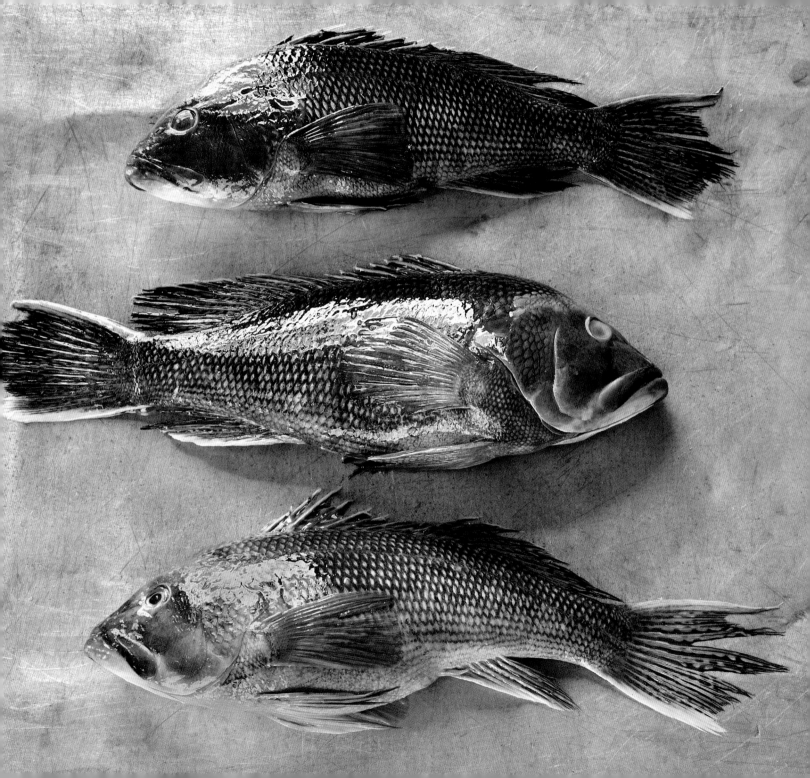

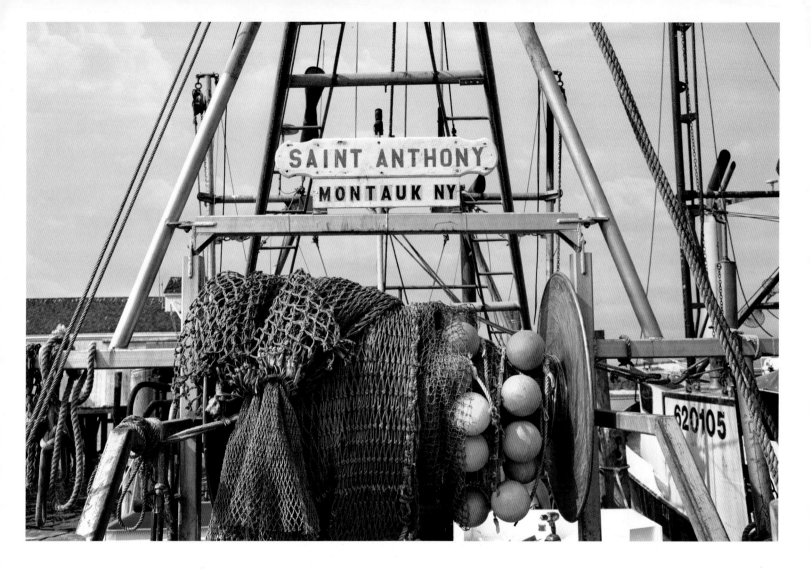

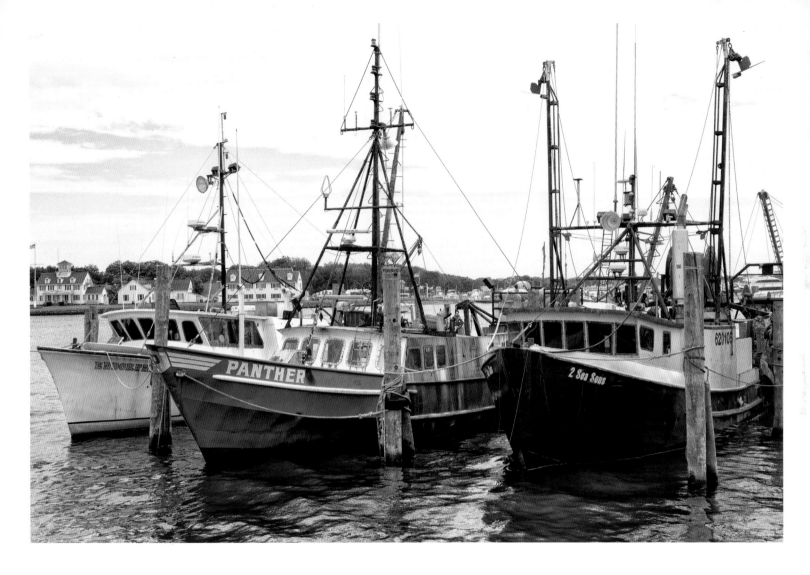

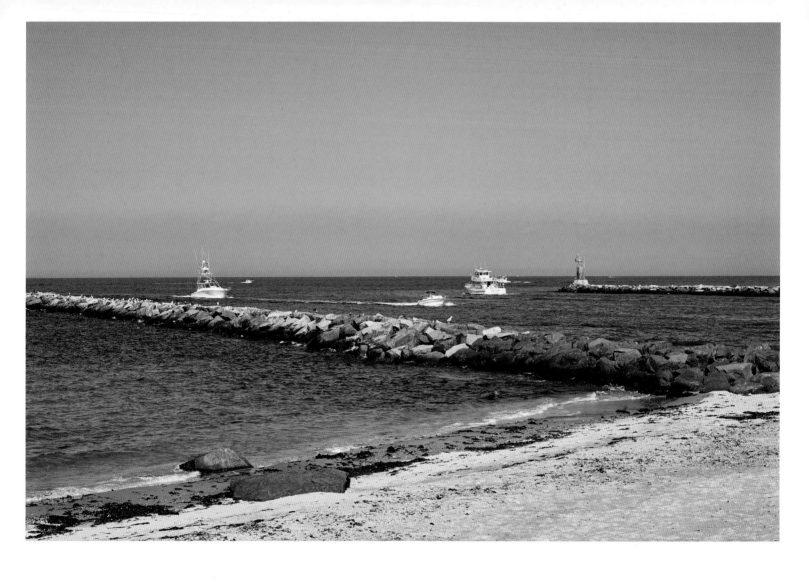

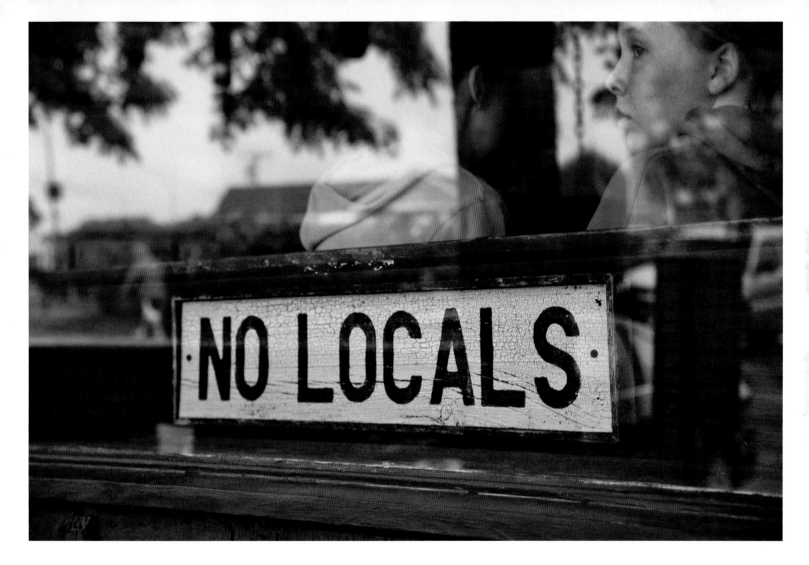

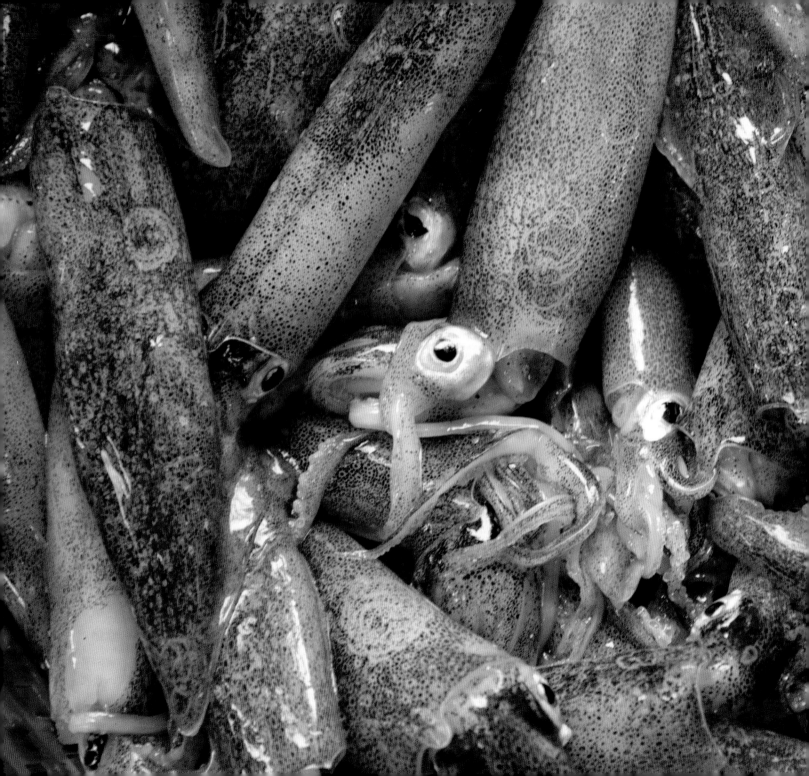

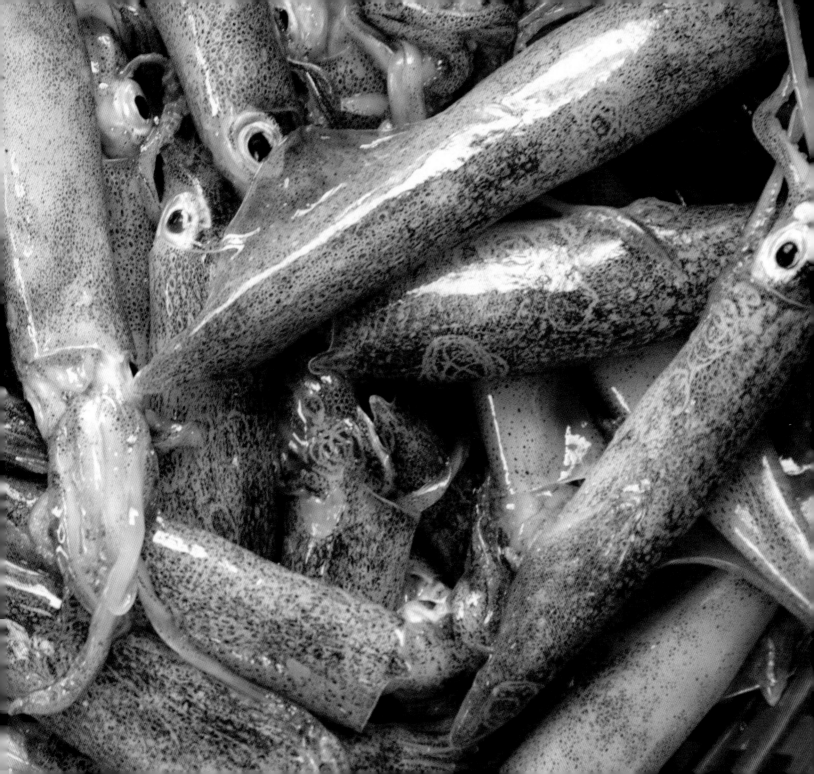

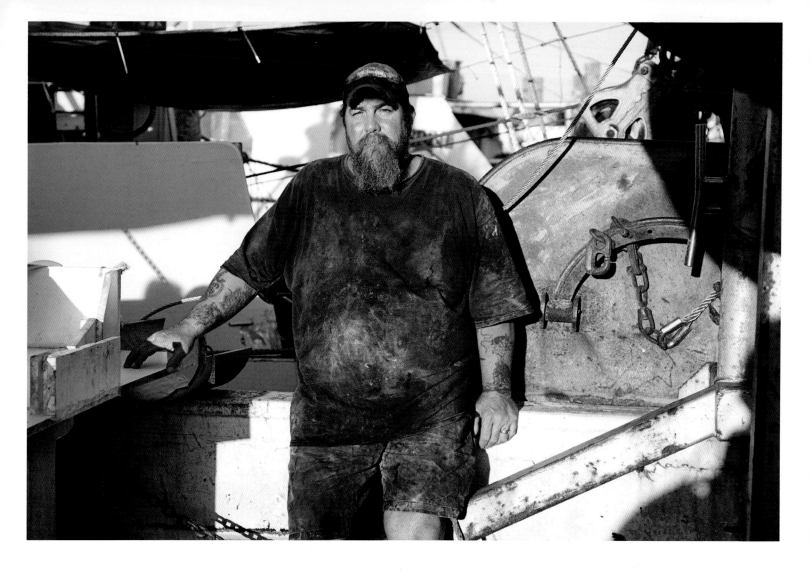

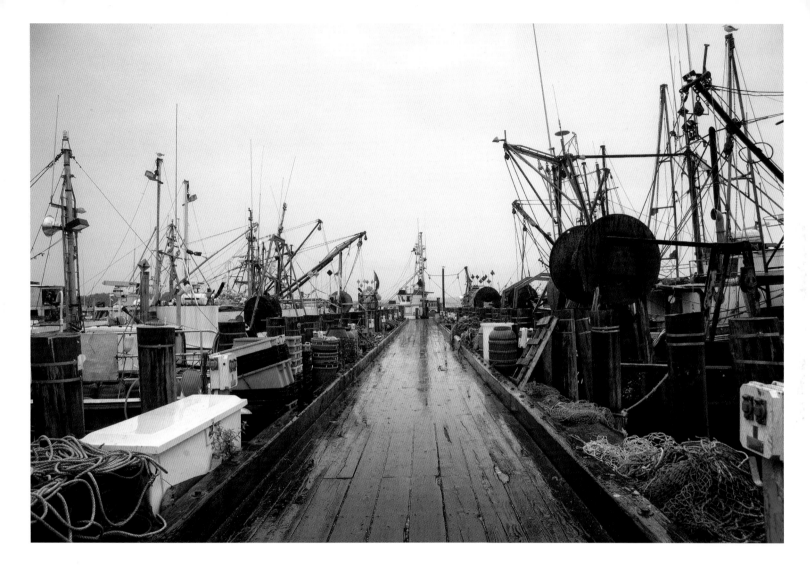

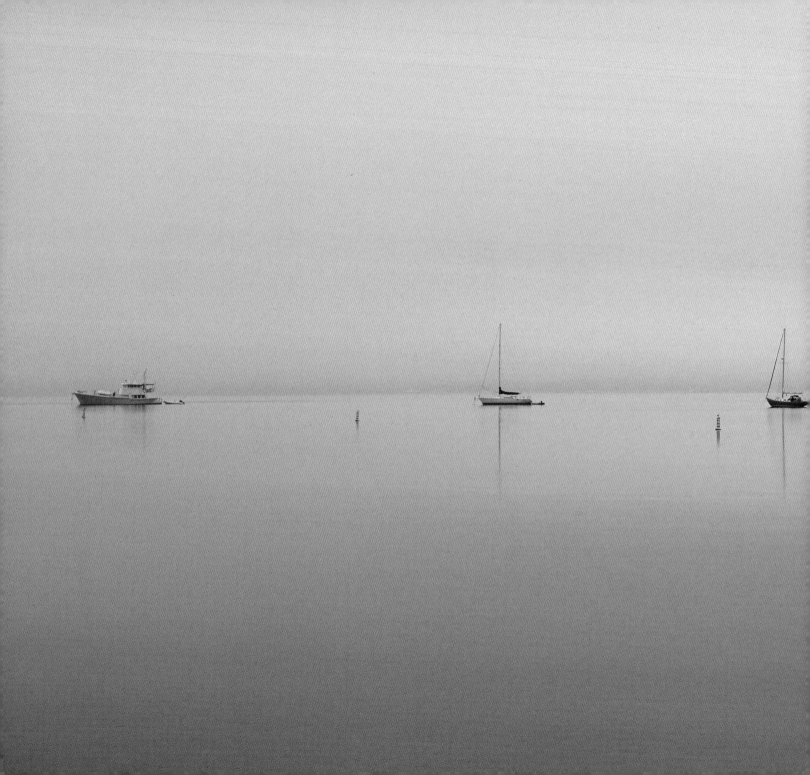

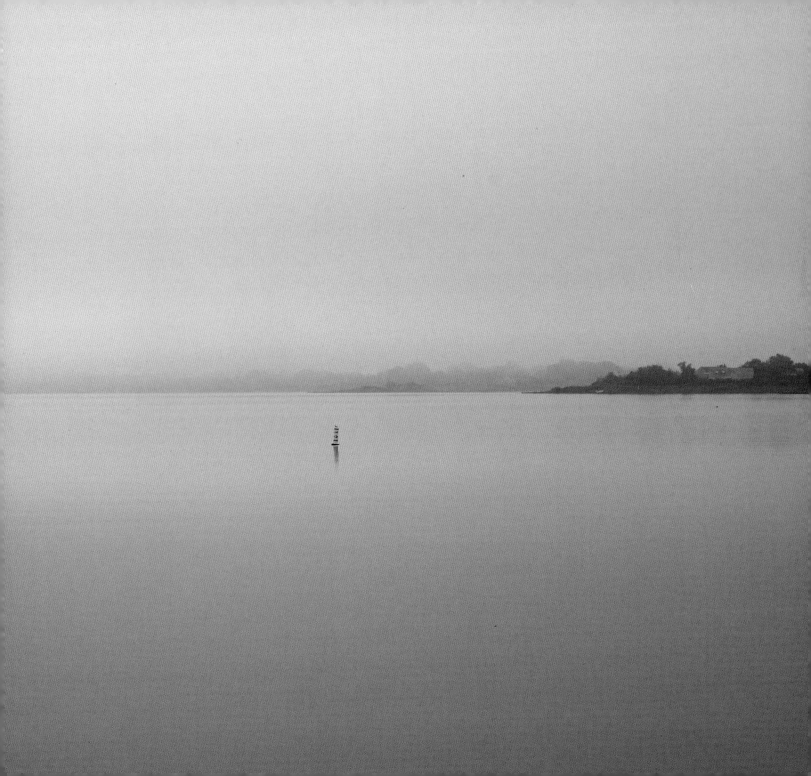

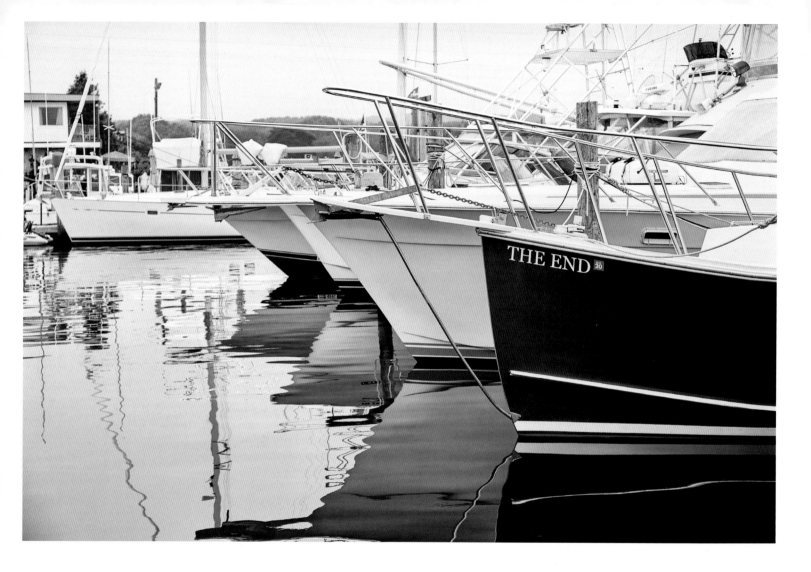

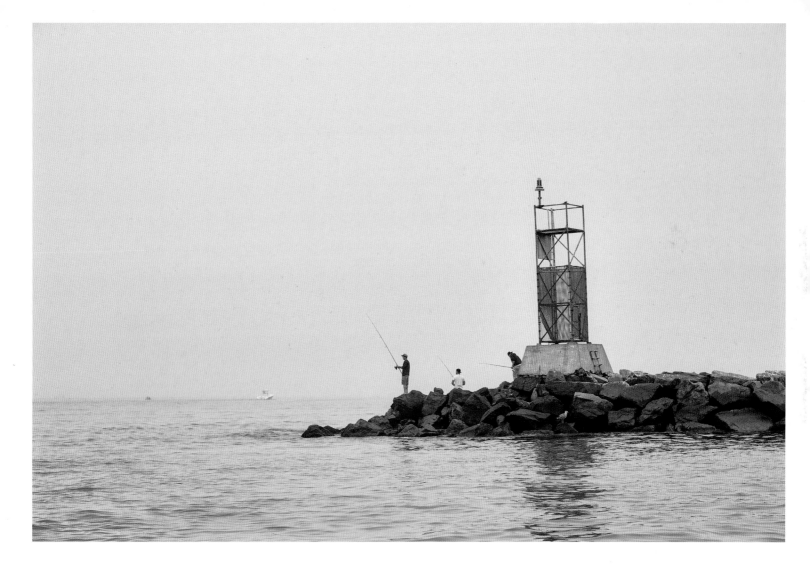

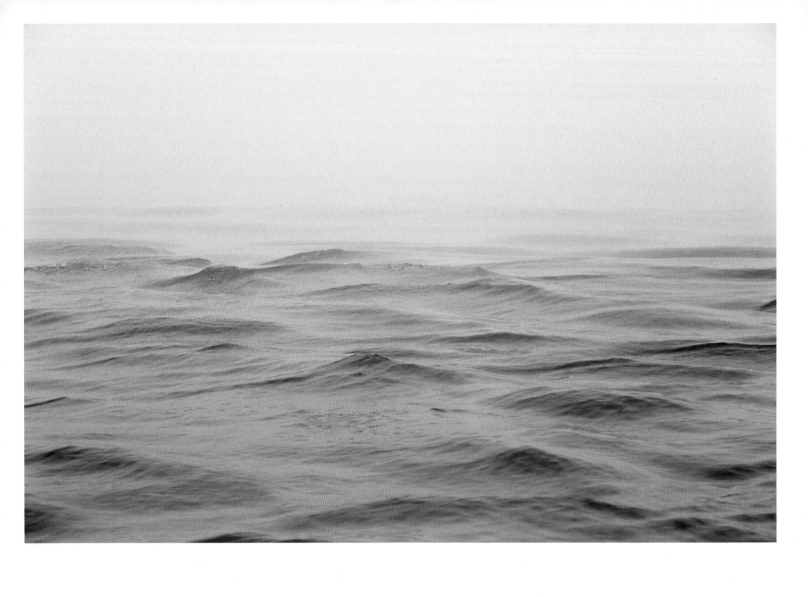

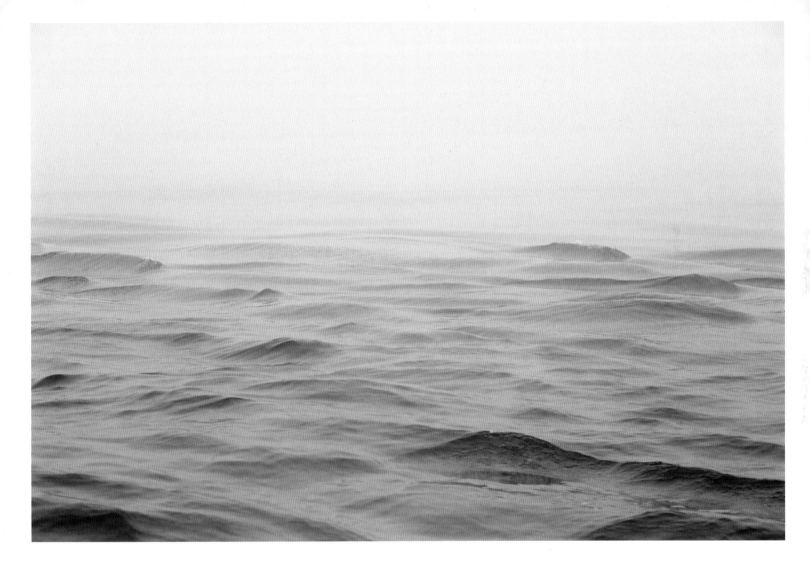

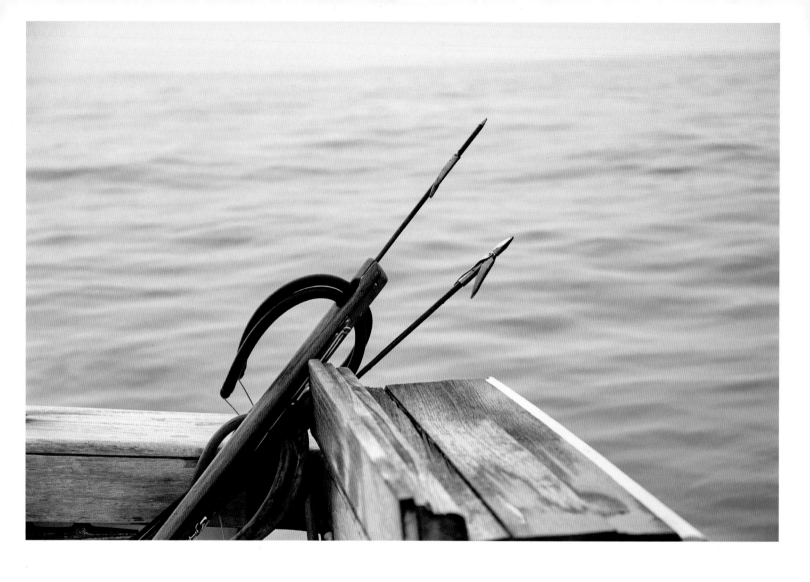

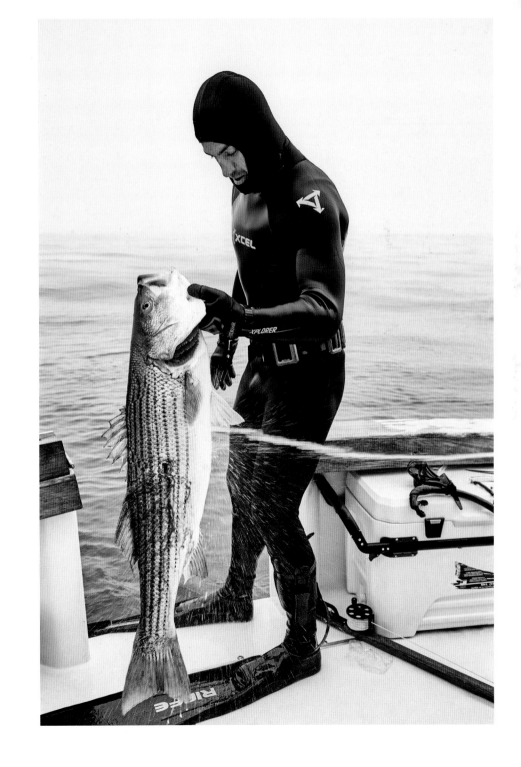

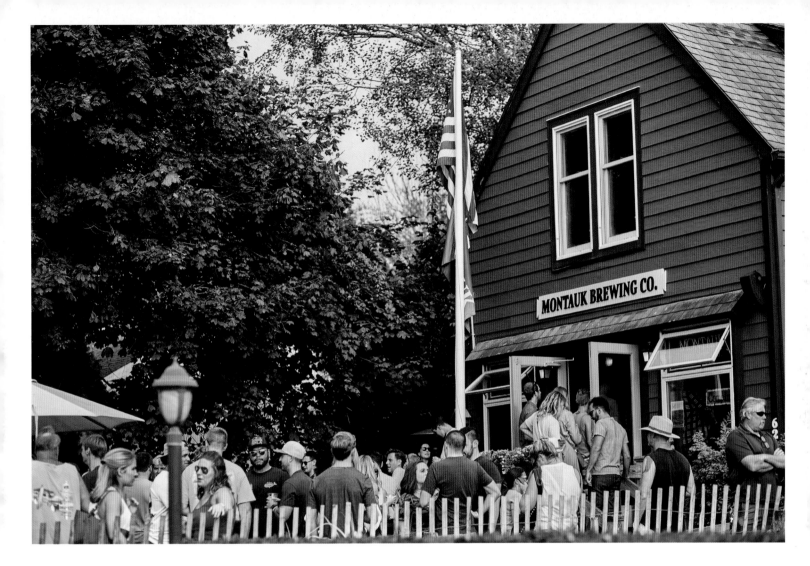

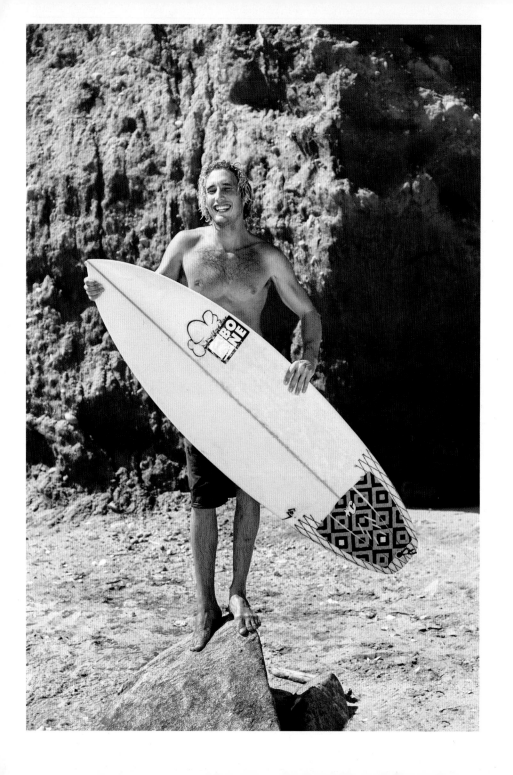

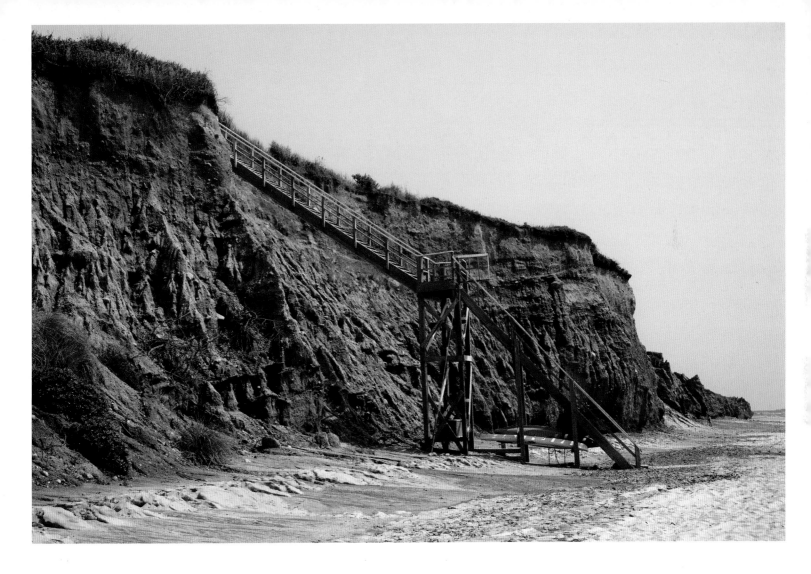

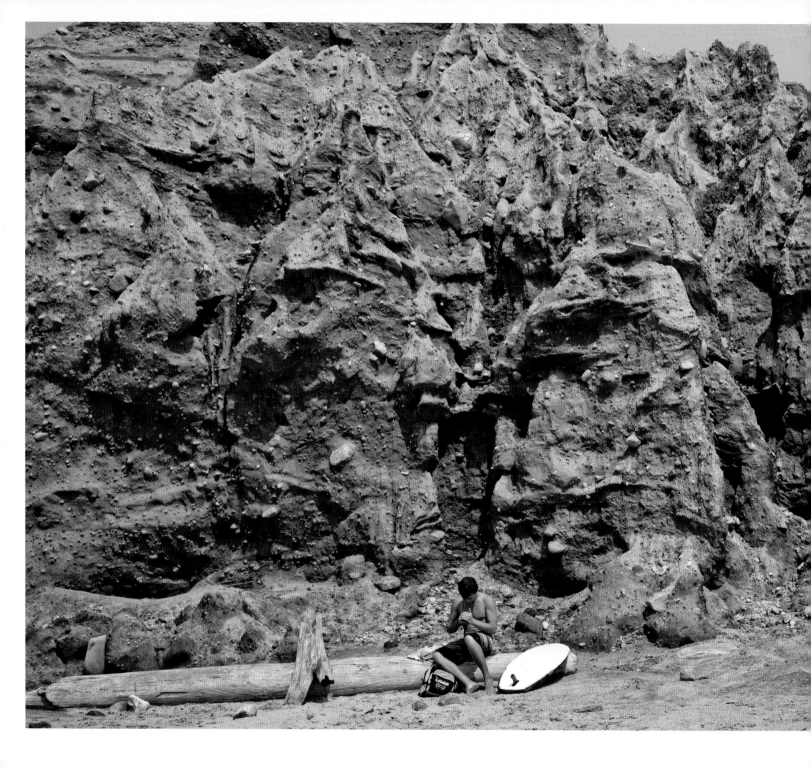

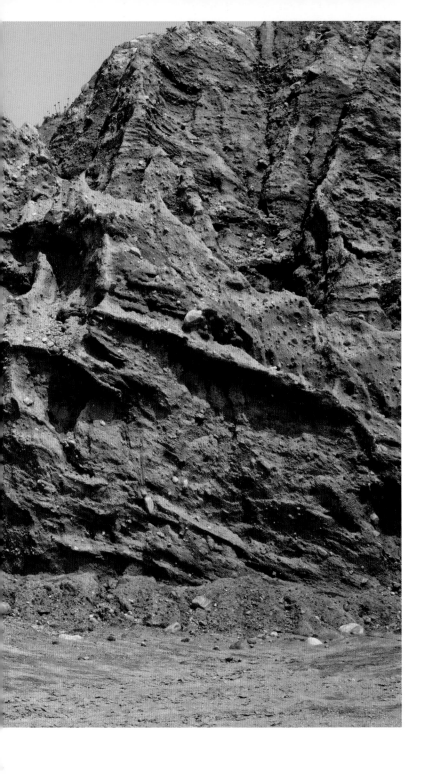

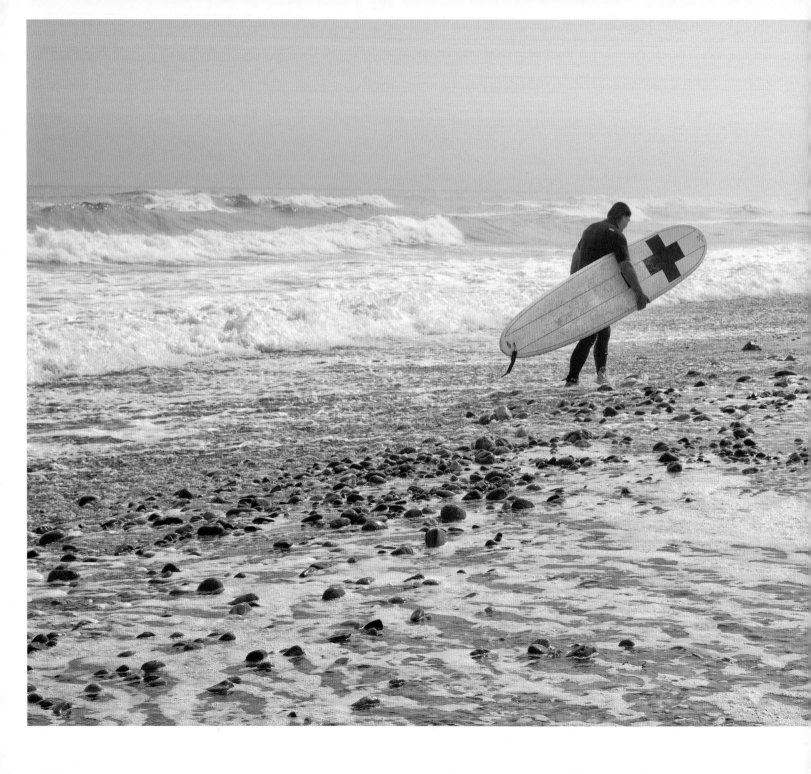

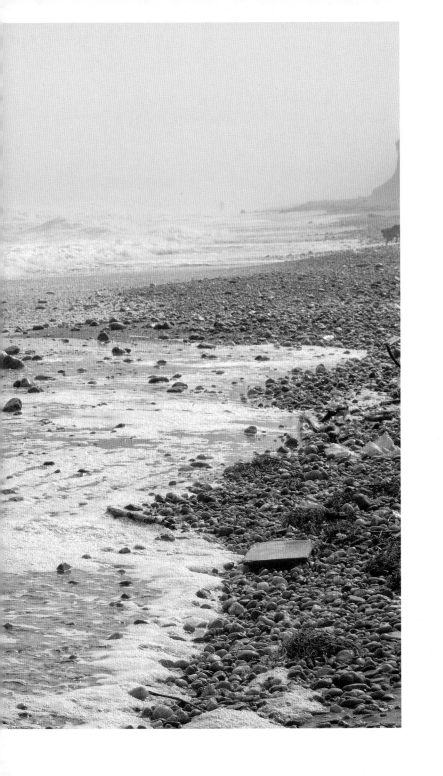

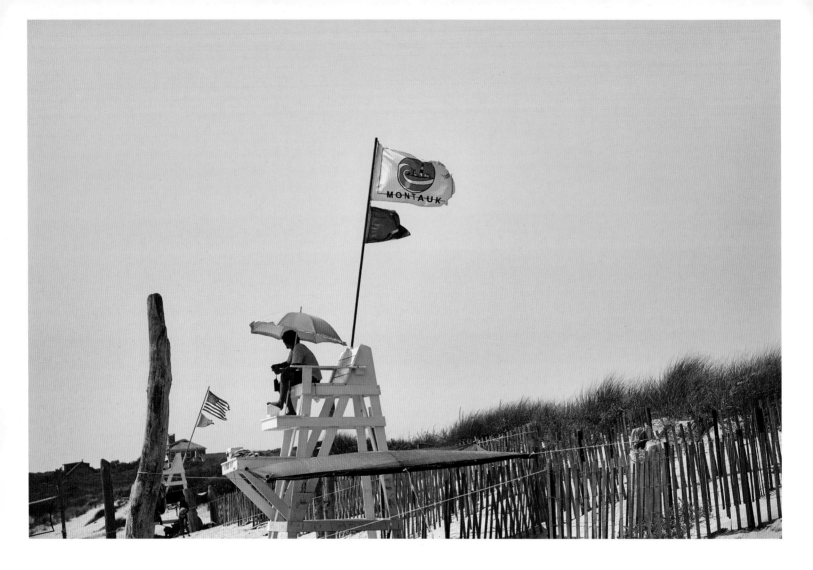

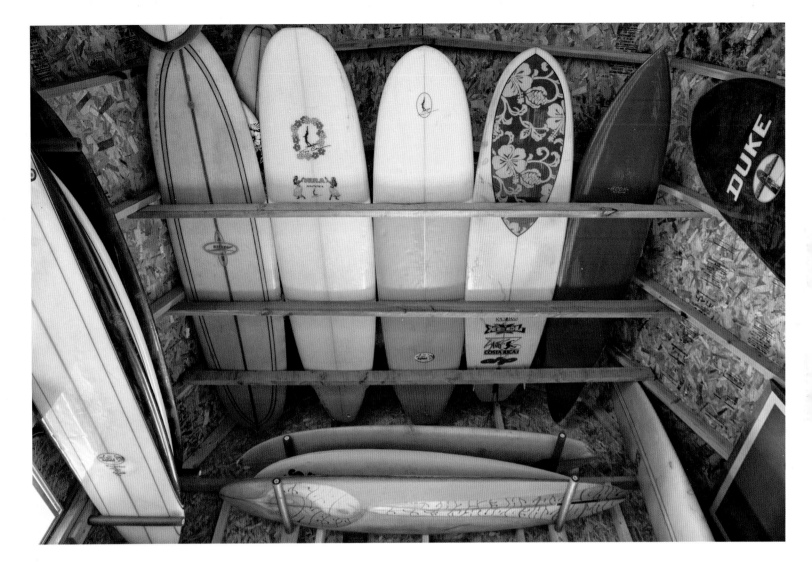

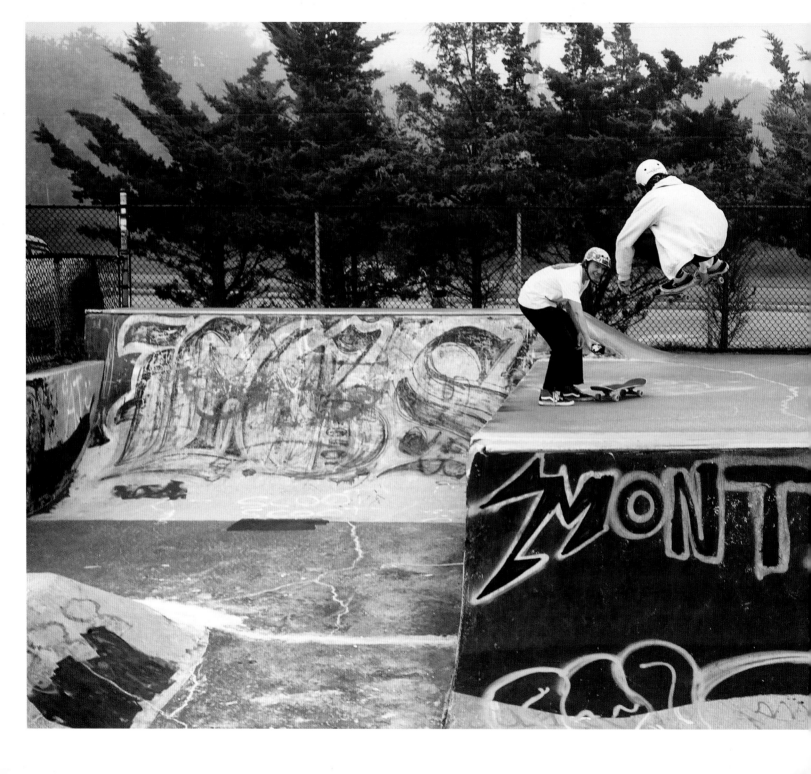

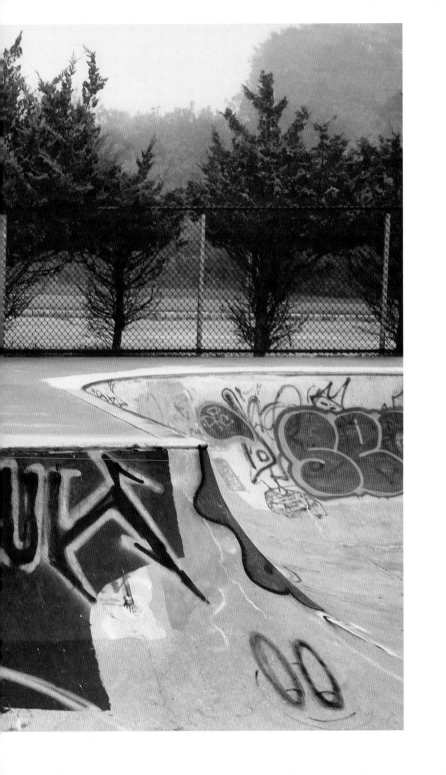

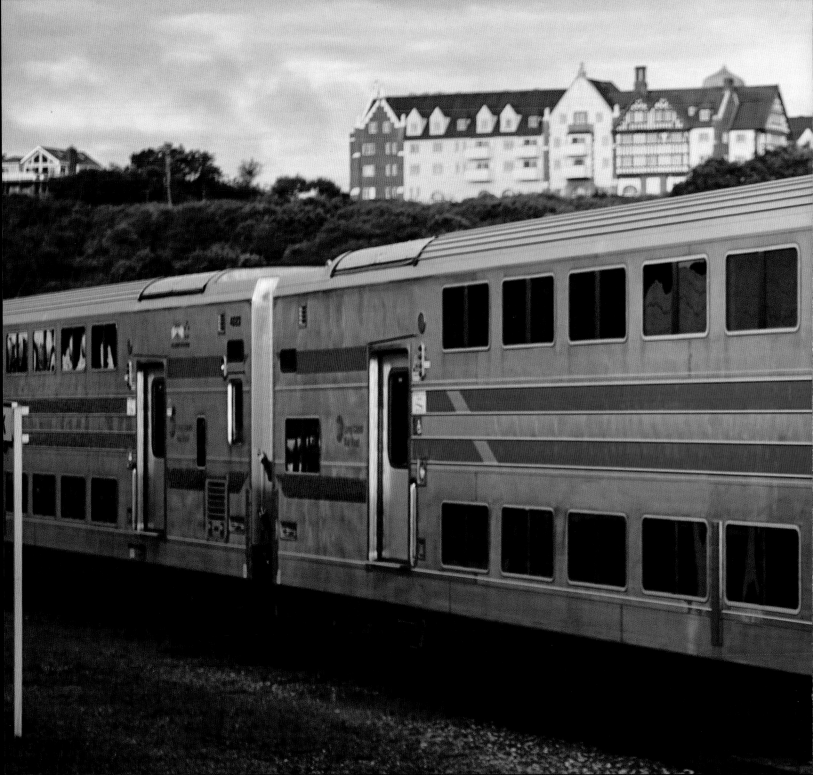

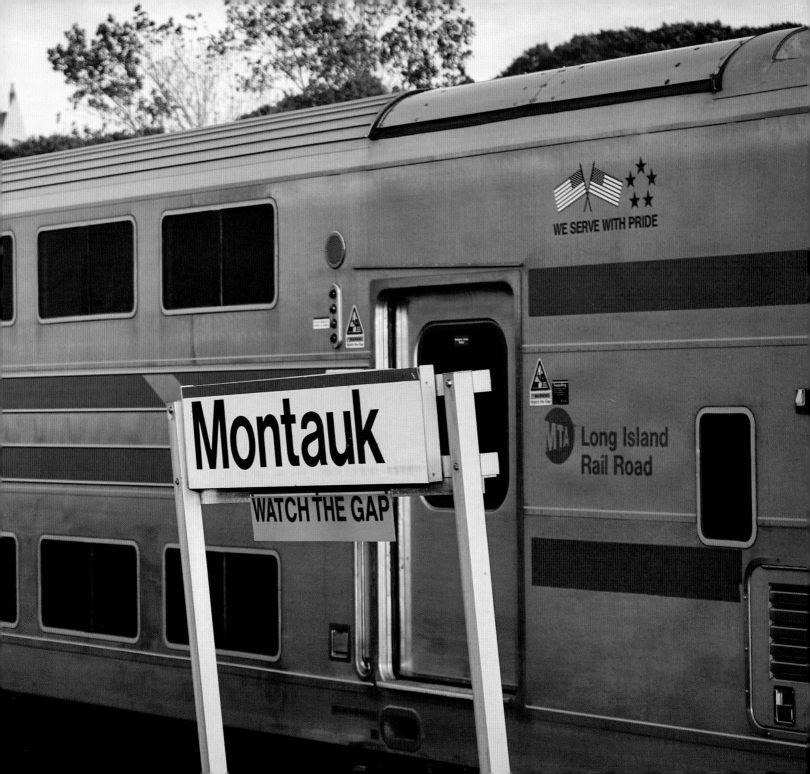

INDEX

Other Schiffer Books on Related Subjects:

Archipelago New York, by Thomas Halaczinsky,
978-0-7643-5507-3

The Ever-Changing Coastline, Joseph R. Votano,
978-0-7643-5487-8

These Hamptons, Phillip Andrew Lehans,
978-0-7643-4331-5

Designed by Jesse Reed, Order
Cover design by Jesse Reed, Order
Type set in Neue Hass Grotesk Black 95

ISBN: 978-0-7643-5605-6
Printed in China

Published by Schiffer Publishing, Ltd.
4880 Lower Valley Road
Atglen, PA 19310
Phone: (610) 593-1777; Fax: (610) 593-2002
E-mail: Info@schifferbooks.com
Web: www.schifferbooks.com

For our complete selection of fine books on this and related
subjects, please visit our website at www.schifferbooks.com.
You may also write for a free catalog.

Schiffer Publishing's titles are available at special discounts
for bulk purchases for sales promotions or premiums. Special
editions, including personalized covers, corporate imprints,
and excerpts, can be created in large quantities for special
needs. For more information, contact the publisher.

We are always looking for people to write books on new and
related subjects. If you have an idea for a book, please contact
us at proposals@schifferbooks.com.

ACKNOWLEDGMENTS

The author would like to thank:

Alice Houseknecht
Connie Giordano Cortese
Lou Cortese
Andrea Anthony
Carl Anthony
Simon Cascante
Peter Correale
Joni Brosnan
Jesse Reed
Greg Mollica
Victor Chu
Schiffer Publishing

None of this would have been possible without all the great people of Montauk, who were so helpful and on board with this project. Thank you.

Carissa "Car" Pelleteri is a portrait photographer and author who was born and raised in New York. Growing up in Brooklyn, she started shooting portraits of herself and her friends at age ten. She is drawn to raw and candid subjects, as well as the ocean and its surrounding landscapes. Her first solo photography show, from her first book, *Surf+Turf: Montauk*, was exhibited at the Montauk Beach House in 2014. Car lives in Hastings on Hudson, New York, with her husband, Vic, and son, Leo.

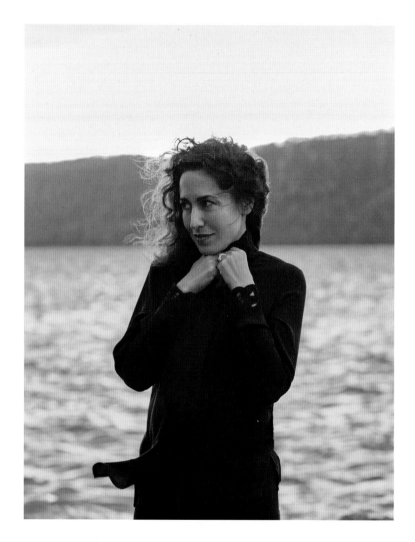

CAR PELLETERI
2017